IMAGES
of America

CENTRAL
MICHIGAN AVENUE

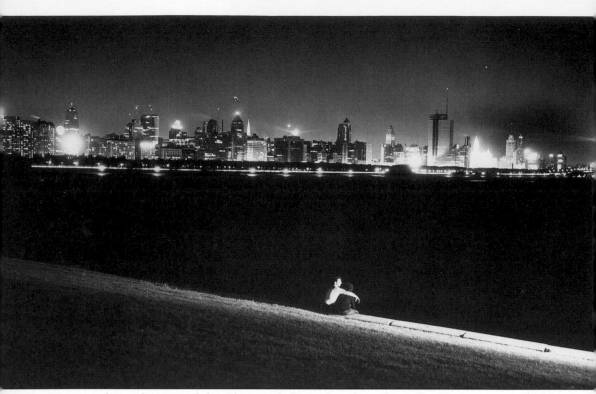

A spectacular night view of the Chicago skyline taken from the Adler Planetarium, *c.* 1956, reveals the many buildings along Central Michigan Avenue.

IMAGES
of America
CENTRAL
MICHIGAN AVENUE

CHICAGO ARCHITECTURE FOUNDATION

Ellen Christensen

ARCADIA

Published by Arcadia Publishing,
an imprint of Tempus Publishing, Inc.
Charleston SC, Chicago, Portsmouth NH,
San Francisco

Printed in Great Britain.

Library of Congress Catalog Card Number: 2003112423

For all general information contact Arcadia Publishing at:
Telephone 843-853-2070
Fax 843-853-0044
E-Mail sales@arcadiapublishing.com
For customer service and orders:
Toll-Free 1-888-313-2665

Visit us on the internet at http://www.arcadiapublishing.com

This book is dedicated to the memory of Paul Ligon who served as president of the Central Michigan Avenue Association from 1991 until 2002. His meaningful contributions to the Avenue will not be forgotten.

The Chicago Architecture Foundation acknowledges the support and assistance of the many organizations and individuals that helped to make this book possible. Special thanks to the Chicago Historical Society, The Chicago Park District, the City of Chicago Department of Planning and Development, Hedrich Blessing, New World Design Partnership, The R. Holden Group, Zurich Esposito, Edward Hirschland, Brian McCormick, and Edward Uhlir.

CONTENTS

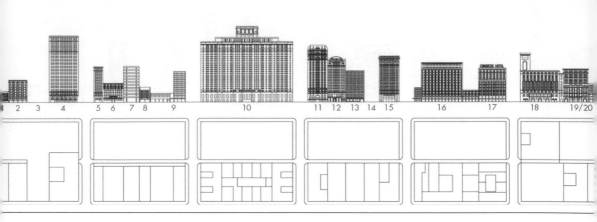

1
Sherwood Conservatory of Music
1014 South Michigan Avenue
Christian Albert Eckstorm, 1912

2
Lightner Building (originally the Graphic Arts Building)
1006 South Michigan Avenue
Edmund R. Krause, 1904

3
Parking Lot
920 South Michigan Avenue

4
Karpen-Standard Oil Building
910 South Michigan Avenue
Marshall & Fox, 1911; addition, Graham, Anderson, Probst & White, 1927

5
Crane Company Building
836 South Michigan Avenue
Holabird & Roche, 1913

6
Young Women's Christian Association
830 South Michigan Avenue
John Van Osdel II, 1895

7
Johnson Publishing Company
820 South Michigan Avenue
Dubin, Dubin, Black & Moutoussam, 1969
Non-contributing

8
East-West Building (originally the American Radiator Building)
816 South Michigan Avenue
Architect unknown, 1903; remodelings, Fridstein & Fitch, 1957, and Seymour Goldberg, 1966
Non-contributing

9
Essex Inn
800 South Michigan Avenue
A. Epstein and Sons, Inc., 1961
Non-contributing

10
Chicago Hilton and Towers (originally the Stevens Hotel)
720 South Michigan Avenue
Holabird & Roche, 1927

11
Blackstone Hotel
636 South Michigan Avenue
Marshall & Fox, 1908

12
South Campus Building, Columbia College (originally the Musical College Building)
624 South Michigan Avenue
Christian Albert Eckstorm, 1908; addition, Alfred S. Alschuler, 1922

13
Spertus College of Judaica (originally the Arcade Building)
618 South Michigan Avenue
William Carbys Zimmerman, 1913; remodeling, McClurg, Shoemaker & McClurg, 1958
Non-contributing

14
Vacant parcel (future site of Spertus College of Judaica, being designed by Krueck & Sexton)
608–614 South Michigan Avenue

15
Main Campus Building, Columbia College (originally the Harvester Building)
600 South Michigan Avenue
Christian Albert Eckstorm, 1907

26
Congress Hotel Annex
538 South Michigan Avenue
Camburas & Theodore, 1958
Non-contributing

17
Congress Hotel (originally the Auditorium Hotel Annex)
520 South Michigan Avenue
Clinton J. Warren, 1893; additions, Holabird & Roche, 1902, 1907

18
Auditorium Building, Roosevelt University
430 South Michigan Avenue
Adler & Sullivan, 189⬤

19
Fine Arts Building (originally th⬤ Studebaker Building)
410 South Michigan Avenue
Solon S. Beman, 1885 addition, 189⬤

20
Fine Arts Annex
408 South Michigan Avenue
Solon S. Beman, 1891 remodeling, 1910

21
Chicago Clu⬤
81 East Van Buren Street
Granger & Bollenbache⬤ 1930

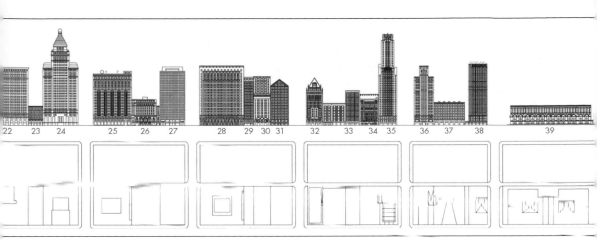

**22
McCormick
Building**
332 South
Michigan
Avenue
*Holabird &
Roche, 1910;
1910*

**23
Karpen
Building**
(originally
Hotel
Richelieu)
318 South
Michigan
Avenue
*Architect
unknown,
1885;
remodeling,
Hessen-
mueller &
Meldahl, 1899*

**24
Britannica
Center**
(originally the
Straus
Building)
310 South
Michigan
Avenue
*Graham,
Anderson,
Probst &
White, 1924*

**25
Santa Fe
Building**
(originally the
Railway
Exchange
Building)
224 South
Michigan
Avenue
*D.H. Burnham
& Company,
1904*

**26
Symphony
Center**
(originally
Theodore
Thomas
Orchestra
Hall)
220 South
Michigan
Avenue
*D.H. Burnham
& Company,
1905;
addition,
Howard Van
Doren Shaw,
1908,
Skidmore,
Owings &
Merrill, 1998*

**27
Borg-Warner
Building**
200 South
Michigan
Avenue
*William
Lescaze with
A. Epstein &
Sons, 1958*
Non-
contributing

**28
People's Gas
Company
Building**
122 South
Michigan
Avenue
*D.H. Burnham
& Company,
1911*

**29
116 South
Michigan
Avenue** (originally the
Municipal
Courts
Building)
*Jenney,
Mundie &
Jensen, 1906;
addition, 1912*

**30
112 South
Michigan
Avenue
Building,
School
of the Art
Institute of
Chicago**
(originally the
Illinois
Athletic Club)
*Barnett, Hayes
& Barnett,
1908;
addition,
Swann &
Weiskopf,
1985*

**31
Monroe
Building**
104 South
Michigan
Avenue
*Holabird &
Roche, 1912*

**32
University
Club**
76 East
Monroe Street
*Holabird &
Roche, 1908*

**33
The Gage
Group**
18, 24, and 30
South
Michigan
Avenue
*Holabird &
Roche (24 and
30), Louis
Sullivan (18),
1900;
alterations,
Holabird &
Roche, 1902,
Altman-
Saichek
Associates,
1971*

**34
Chicago
Athletic
Association
Building**
12 South
Michigan
Avenue
*Henry Ives
Cobb, 1893*

**35
Willoughby
Tower**
8 South
Michigan
Avenue
*S.N. Crowen
& Associates,
1929*

**36
6 North
Michigan
Avenue**
(originally the
Montgomery
Ward &
Company
Building)
*Richard E.
Schmidt,
1899;
addition,
Holabird
& Roche,
1923*

**37
Smith,
Gaylord &
Cross
Building**
20 North
Michigan
Avenue
*Architect
unknown,
1882;
addition,
Beers,
Clay &
Dutton, 1891*

**38
30 North
Michigan
Avenue
Building**
(originally the
Michigan
Boulevard
Building)
*Jarvis Hunt,
1914;
addition, 1923*

**39
Chicago
Cultural
Center**
(originally the
Chicago
Public
Library)
78 East
Washington
Street
*Shepley,
Rutan &
Coolidge,
1897;
restoration,
Holabird &
Root, 1977*

MISSION STATEMENT

The Chicago Architecture Foundation (CAF) is dedicated to advancing public interest and education in architecture and related design. CAF pursues this mission through a comprehensive program of tours, exhibitions, special programs, and youth programs, all designed to enhance the public's awareness and appreciation of Chicago's outstanding architectural legacy.

Founded in 1966, the Chicago Architecture Foundation has evolved to become a nationally recognized resource advancing public interest and education in Chicago's outstanding architecture. Its programs serve more than 350,000 people each year. For more information contact us at the address below or visit us on our website.

CHICAGO ARCHITECTURE FOUNDATION

224 South Michigan Avenue
Chicago, IL 60604
www.architecture.org
312-922-TOUR

INTRODUCTION

TRANSFORMATIONS: 1860–2003

Central Michigan Avenue has undergone many transformations throughout its long history. Today the portion of Michigan Avenue between the Chicago River and Roosevelt Road consists of green parkland along the lakefront and an eclectic grouping of modern and vintage buildings along the edge of Chicago's urban grid. This book examines the development of the area from the 1860s to the dawn of the 21st century.

In the years following the founding of Chicago in 1837, the area grew from a marshy piece of lakefront property. By the 1860s Michigan Boulevard, as it was then called, was a genteel residential neighborhood filled with gracious residences. In 1871 the great Chicago Fire destroyed the downtown area of Chicago, reducing the fashionable boulevard to a pile of smoldering rubble. After the fire the area was built anew. No longer a genteel residential neighborhood, in the 1880s the avenue was reborn as a major cultural and commercial corridor.

The avenue is one of only five worldwide to have a long row of buildings on one side and parkland and water on the other. The streetwall to the west consists of vintage and contemporary structures with the oldest built in the years following the great Chicago Fire of 1871. Buildings designed by famous Chicago architects, such as the 1899 Gage Building by Louis Sullivan and the 1910 People's Gas Building by Daniel Burnham, suggest the splendor of turn-of-the-century Chicago.

The development of parkland along the lakefront accompanied the reinvention of the area. Grant Park dominates the east side of the street from Jackson Boulevard to Congress Parkway. Originally called Lake Park, the area was created in part from landfill in the late nineteenth century. Situated in this green space, the Art Institute of Chicago presides over the avenue between Monroe Street and Jackson Boulevard.

Since the late nineteenth century, concentrated efforts to develop disparate areas along the avenue have lent it a fragmented, eclectic quality. Although architects have proposed grand plans to unify the avenue aesthetically and functionally, such plans have been carried out only in a piecemeal manner over time. Daniel H. Burnham's 1909 Plan of Chicago envisioned the avenue as a grand boulevard in the European tradition, a magnificent thoroughfare lined with neoclassical buildings, plazas, fountains, and sculpture looking out over a grand park toward Lake Michigan. Although the mixture of structures and spaces that comprise the avenue do not reflect Burnham's ideas of classical scale, uniformity, and symmetry, the formal design of Grant Park was shaped by his vision. Despite continued efforts to impose some uniformity of vision along Central Michigan Avenue, the area continues to be an exuberant jumble of design elements. Gleaming modern office towers stand shoulder to shoulder with fine Art Deco

structures and nineteenth-century office buildings designed in historical styles such as Venetian or Collegiate Gothic. Variety is still the essence of the avenue's charm.

Today the intensive re-development of portions of the avenue continues. In 2003 architects such as Lucien LaGrange were engaged in the conversion of vintage structures to new uses. For example, the stunning Art Deco Carbide and Carbon Building, constructed in 1929 by Burnham Brothers, is undergoing conversion from an office building to a hotel. Between Balbo Drive and Roosevelt Road, the potential rehabilitation of vintage buildings such as the Blackstone Hotel and the conversion of 836 South Michigan Avenue to upscale residences bring new life to an area once plagued by urban blight. A mixture of residences and well-established institutions such as Columbia College and the Spertus Museum dominate this section of the avenue. Several older buildings near Roosevelt Road are undergoing rehabilitation, and new condominiums will dominate the corner of Michigan Avenue and Roosevelt Road. This area constitutes a potential link to the Museum Campus and South Loop residential enclaves.

In 2003 significant development along Central Michigan Avenue took place at the northeast corner of Randolph Street and Michigan Avenue. Here, a peristyle, a semi-circle of columns, marks the transition from Randolph Street to the new Millennium Park. The park features an unusual metal-clad bandshell designed by the internationally renowned architect Frank Gehry. With its many acres of green space, its bandshell, ice rink, and other amenities, Millennium Park is a crucial point of repose along the busy avenue.

Central Michigan Avenue is an unusual blend of green space combined with cultural, commercial, and residential buildings overlooking Lake Michigan. As such, it is one of the premier destinations in the city. Through its many transformations, the avenue has become the heart of Chicago, as it is a necessary point of transition from the lakefront to the edge of the city grid. Ever changing, Central Michigan Avenue is one of the city's most contradictory and captivating areas.

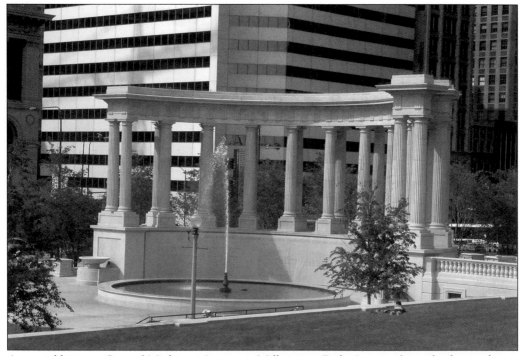

A new addition to Central Michigan Avenue is Millennium Park. A peristyle marks the northwest corner of the park at Randolph Street and Michigan Avenue. (Courtesy of Anne Evans.)

One

THE EARLY AVENUE
1860–1880

In the 1860s Michigan Boulevard, as Michigan Avenue was then called, looked out onto an industrial landscape. The lakefront was not bounded by the enticing green space that it is today. Standing near the downtown shoreline looking north toward the Chicago River, one could see wharves, dirt beaches, factories, and a trestle for the Illinois Central Railroad.

Despite the gritty nature of the lakefront, the area along Michigan Boulevard was considered elegant. The genteel, tree-lined street featured many picturesque townhouses built in cream-colored stone. As many visitors attested, the fashionable Italianate and French-inspired structures along the boulevard evinced the taste and wealth of early Chicagoans.

In October 1871 the scene changed dramatically. The great Chicago Fire destroyed a large portion of the city. The fire burned from Twelfth Street north to Fullerton Avenue, an area of nearly four square miles, with the loss of property totaling more than two hundred million dollars. The fashionable homes along Michigan Boulevard were reduced to smoldering ruins.

In the years after the fire, makeshift structures were constructed along the street. After the City Council banned wooden construction within the downtown area, buildings were constructed of fireproof materials such as brick and stone. No longer a fashionable residential neighborhood, in the 1880s the area was reinvented as a cultural and commercial corridor.

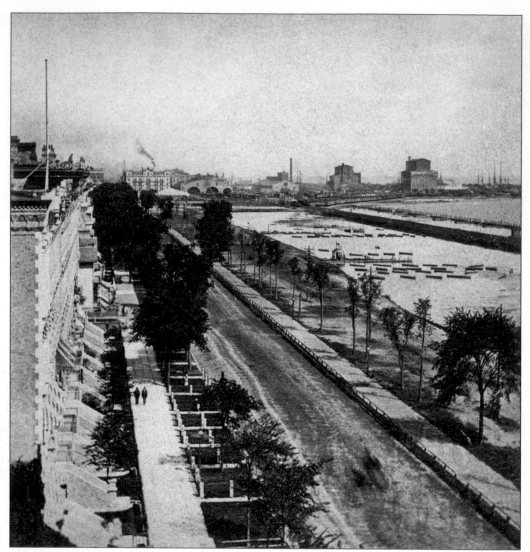

Lake Park, known today as Grant Park, and Michigan Boulevard, *c.* 1868.

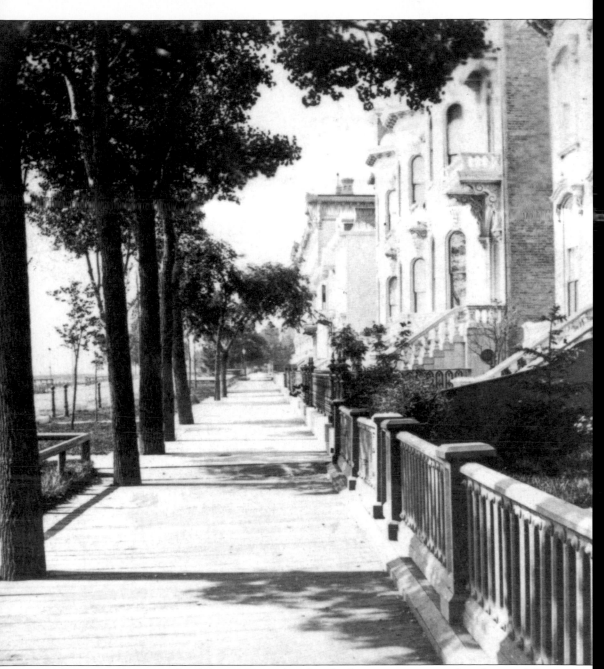

By the 1860s, the west side of the street was lined with elegant mansions and rowhouses. The boulevard was home to many prominent families and even the Roman Catholic bishop. This stereograph shows Michigan Boulevard south from Jackson Street. Facing the lakefront, these residences enjoyed ample sunlight and pleasant lake breezes.

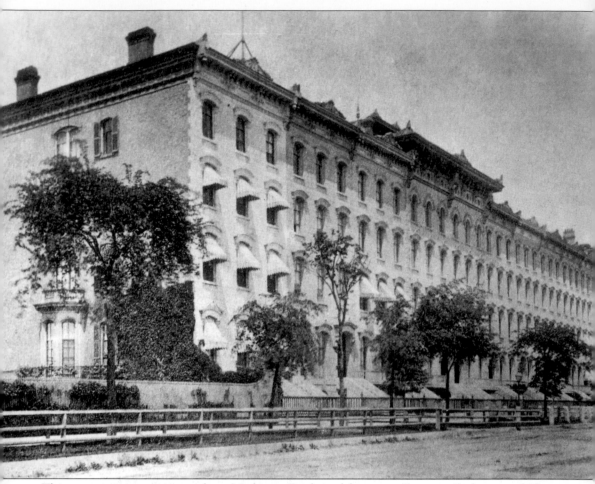

This terrace row was situated on Michigan Boulevard between Congress Parkway and Van Buren Street. Italianate in style, residential buildings of this kind were commonplace on the boulevard until the Chicago Fire of 1871. The Italianate style was the dominant architectural style in urban America until the 1890s. Imported from Europe, the style was derived in part from the formal Italian Renaissance townhouses from the 15th and 16th centuries. Typical features of Italianate-style buildings include arched windows and doorways and elaborate cornice treatments, as shown on this set of townhouses.

The Italianate-style William Blair Residence, built in 1856, was located at 230 South Michigan Boulevard.

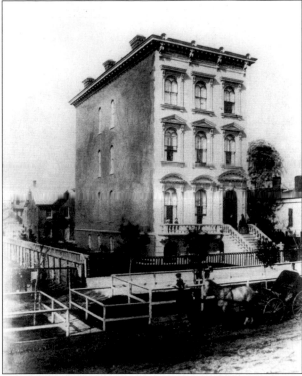

Another Italianate-style house, the Lyman Blair Residence, was located at 274 South Michigan Boulevard.

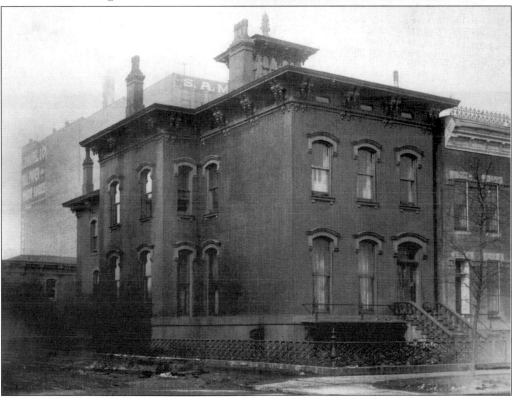

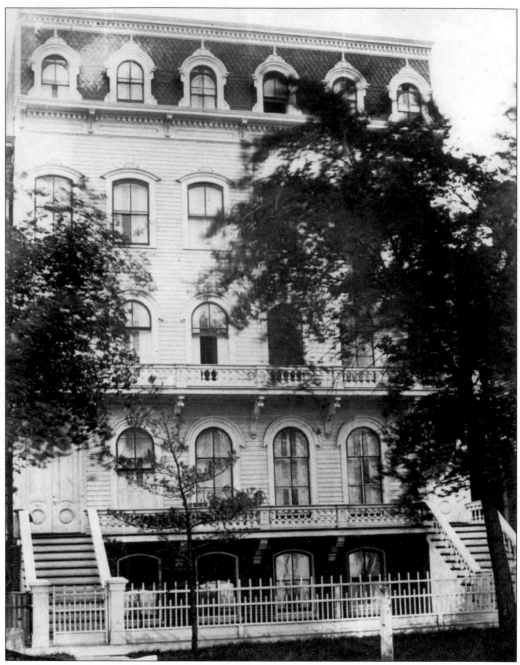

Townhouses once stood where many of Michigan Avenue's large commercial buildings stand today. The townhouses in this 1868 image were located at 281-282 Michigan Boulevard.

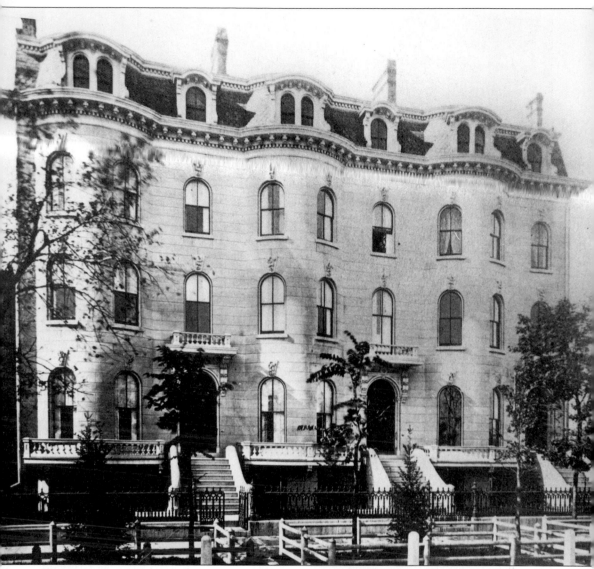

The adjoining residences of the Bowen brothers, James, George, and Chauncey, were located at 124, 125, and 126 Michigan Boulevard.

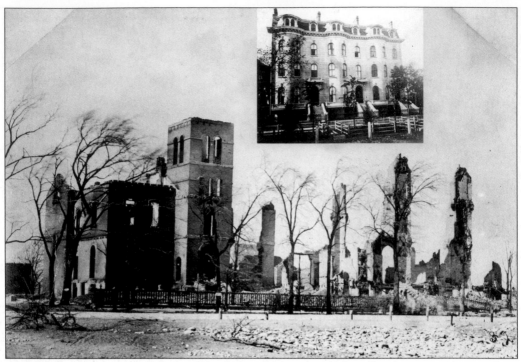

The Chicago Fire of 1871 destroyed the downtown area, including the elegant residences along Michigan Boulevard. These photographs show before and after shots of the Bowen Brothers homes at 124, 125, and 126 Michigan Boulevard.

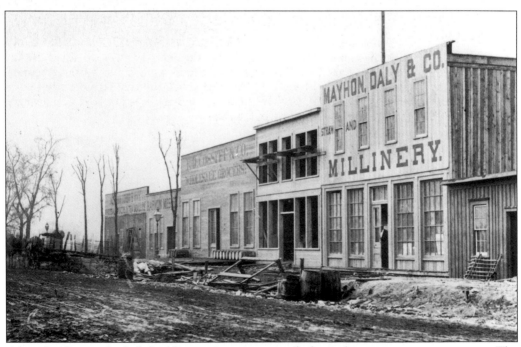

After the fire, makeshift buildings were constructed along the once-prosperous street. The photograph shows commercial buildings between Adams and Monroe Streets.

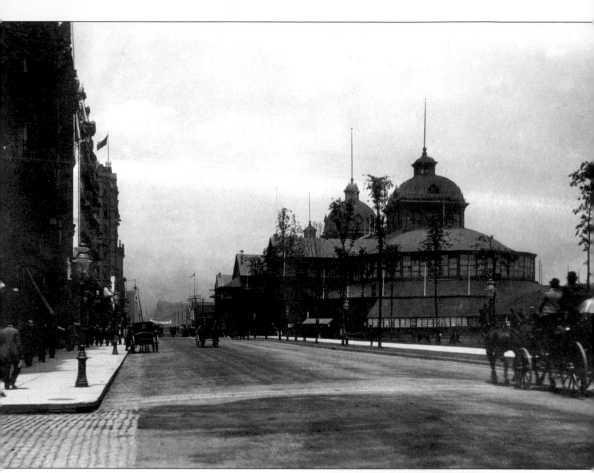

The Inter-State Industrial Exposition Building, right, designed by the architect W.W. Boyington, was constructed in Lake Park (known today as Grant Park) in 1873 as a temporary building to house a public exhibition of goods and farm equipment. It also served as the site of the 1884 Republican National Convention. The building was demolished in 1891 to make way for a permanent building for the Art Institute of Chicago.

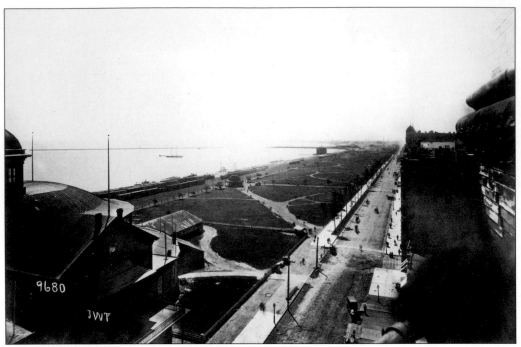

This view of the boulevard from the late 1880s shows the beginnings of the commercial streetwall to the west, at right. To the east is Lake Park, with the Inter-State Industrial Exposition Building in the foreground.

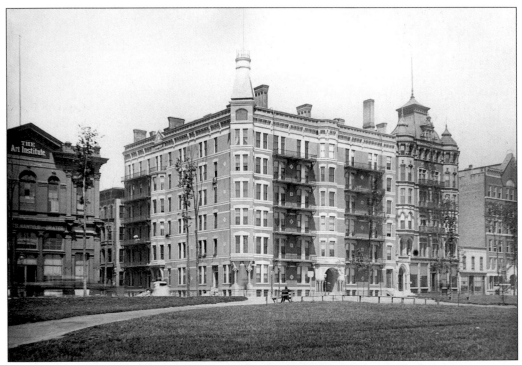

A view from the 1880s shows the Victoria Hotel, a sprawling Victorian Gothic structure.

Two

THE GOLDEN AGE

1880–1929

In the 1880s the construction of the Auditorium Building at the corner of Michigan Avenue and Congress Parkway established the avenue as an important cultural corridor within the city. The Auditorium Building was an imposing mixed-use structure that included a hotel, a theater, and offices. Designed by the firm of Adler & Sullivan, the building housed the premier performance space in the city, renowned for its fine acoustics.

Many culturally related buildings were constructed along the avenue in the years that followed, including the Art Institute of Chicago in 1893, the Chicago Public Library in 1897, and Symphony Center (formerly Orchestra Hall) in 1905. The Studebaker Building, originally constructed for the carriage and automobile manufacturer, became the Fine Arts Building in 1898. This structure, designed by Solon S. Beman, provided spaces for artists, writers, musicians, and architects, including Frank Lloyd Wright.

Cultural buildings shared the avenue with substantial commercial structures designed by Chicago School architects such as Louis Sullivan, Daniel Burnham, and Holabird & Roche. Among these structures were offices such as the 1904 Railway Exchange Building and private clubs such as the 1908 University Club. By 1920 the avenue was a prime destination within the city supporting commerce and the arts.

The Congress Hotel, designed by Clinton J. Warren and Holabird & Roche, stands at 520 South Michigan Avenue. Originally built as an extension of the Auditorium Hotel, the structure echoes the design of the Auditorium immediately to the north.

CULTURE

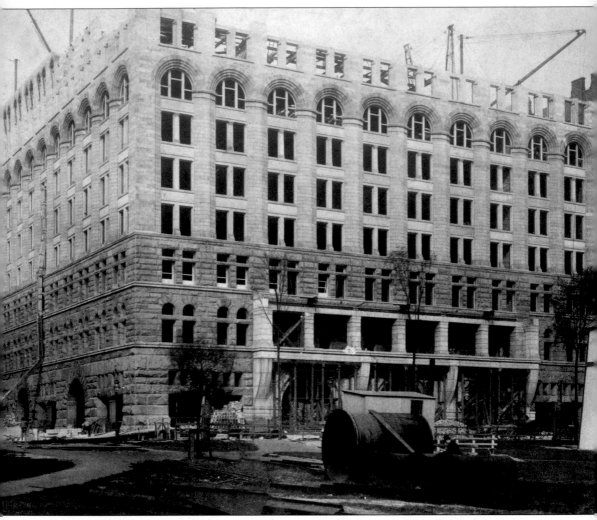

Dankmar Adler and Louis Sullivan's Auditorium Building at 430 South Michigan Avenue appears under construction in October 1888. At the time of its dedication one year later the Auditorium was America's largest privately owned building and, with 4,200 seats, the nation's most capacious theater. In addition to its spectacular theater, the building contained offices and a hotel, harmoniously combining culture with commerce. Today the Auditorium Building is home to Roosevelt University.

THE CITY OF CHICAGO.

SUPPLEMENT TO HARPER'S WEEKLY, JUNE 23, 1888.

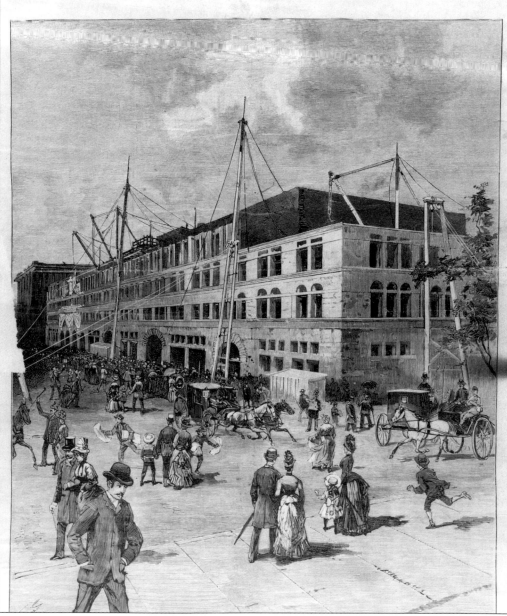

An engraving, published in Harper's Weekly, indicates that the Auditorium Building would be the site of the 1888 National Republican Convention. The convention was held in the unfinished building.

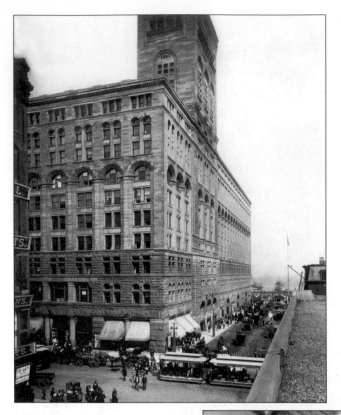

Adler and Sullivan placed the entrance to the Auditorium Building theater on Congress Street. The grand entrance to the building, prominent on Michigan Avenue, led to the hotel lobby.

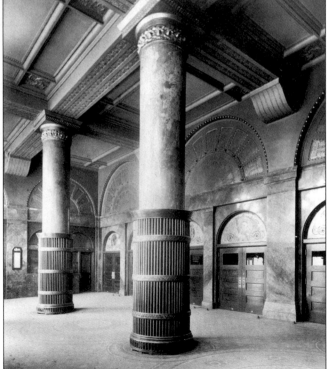

The hotel lobby, *c.* 1895, sported molded plaster decorations on the ceiling, mosaic floors, and faux-marble columns.

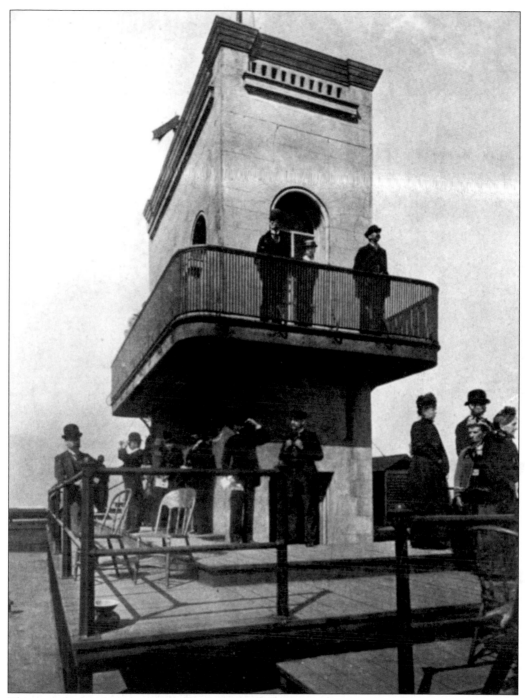

The noted photographer J.W. Taylor captured the government weather bureau atop the Auditorium's tower in this historic image, c. 1894. Tourists were drawn to the lofty site overlooking all of Chicago, including Michigan Avenue and the lakeshore.

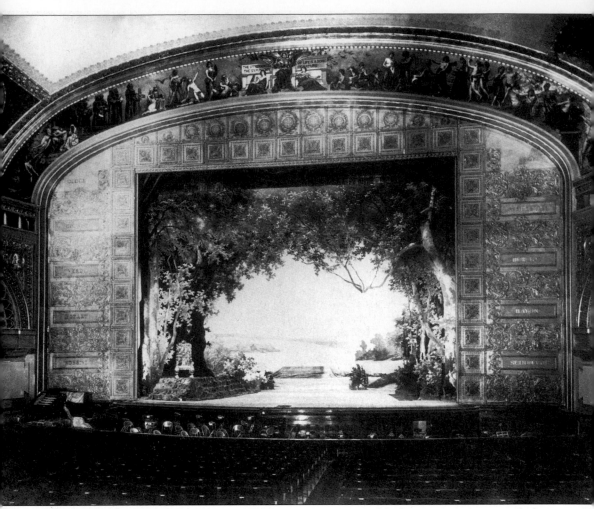

The Auditorium Theater was renowned for its acoustics and lush ornamentation, including gilded plaster and painted murals. This photograph shows the stage *c.* 1889.

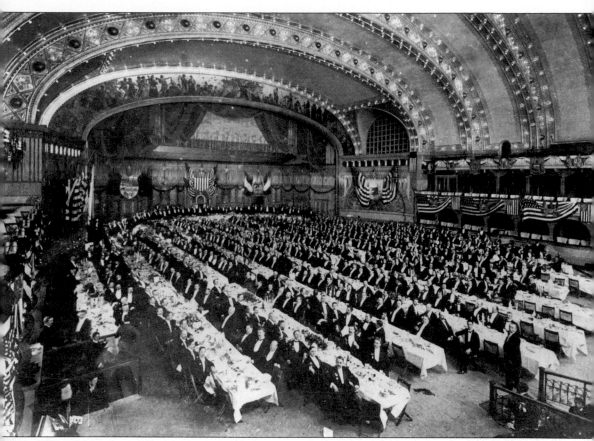

The Auditorium Theater was a grand setting for a banquet. The building also included a dedicated banquet hall and a dining room.

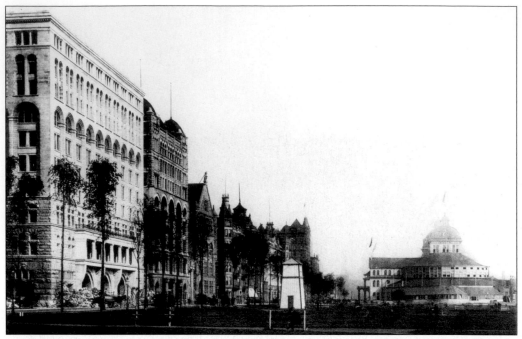

In the late nineteenth century, the row of culturally related buildings took shape on the west side of the Avenue. The Auditorium Building, far left, stands beside the Studebaker Building, later named the Fine Arts Building. Both structures feature round, Romanesque arches. On the east side of Michigan Avenue, the Inter-State Industrial Exposition Building (right) would be demolished in 1892 for the construction of the Art Institute of Chicago.

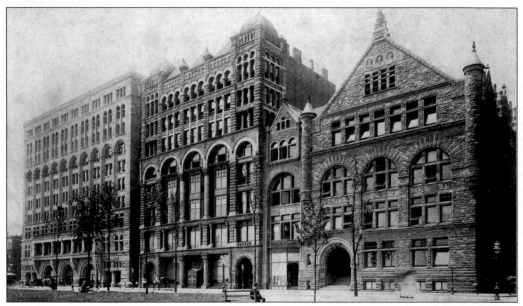

This Romanesque-inspired structure (right) located at the corner of Van Buren and Michigan was the home of the Art Institute of Chicago until 1893. Designed by Burnham & Root, the building later became the home of the Chicago Club. In 1929, it was replaced with a building by Granger and Bollenbacher.

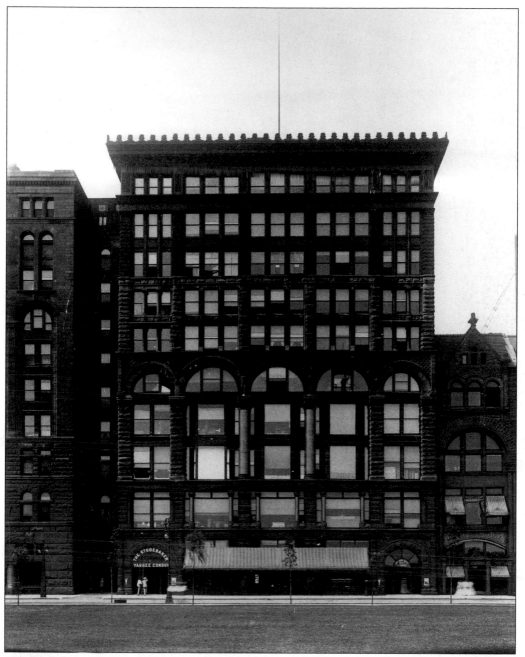

The Studebaker Building, later named the Fine Arts Building, originally housed the offices and showrooms of the Studebaker Carriage Works, a manufacturer of automobiles. Designed by Solon S. Beman and completed in 1885, the building later housed more artistic concerns, including two theaters (now closed). The Fine Arts Annex (right), also designed by Beman, was added in 1891.

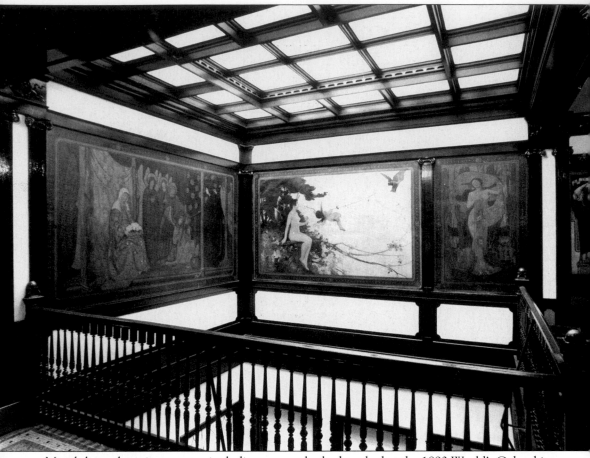

Murals by early artist-tenants, including many who had worked at the 1893 World's Columbian Exposition, grace the walls of the top floor of the Fine Arts Building (formerly the Studebaker Building) and remind visitors of the building's artistic roots.

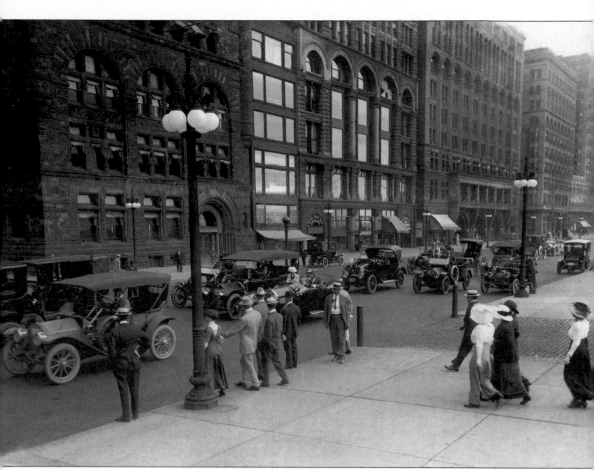

Brisk automobile and pedestrian traffic have long been characteristic of Central Michigan Avenue. Streetlights, known as "boulevard electoliers," were installed on the avenue in 1910–1915 to light the way when the street was widened from two to four lanes of traffic. Classically detailed, the graceful iron poles support a ring of glass globes for illumination. In the 1950s the original electroliers were replaced with standard, modern streetlights. A 1998 streetscape improvement program resurrected the historic electrolier design that once again graces the avenue.

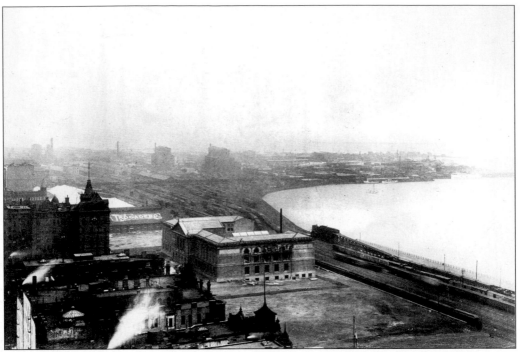

J.W. Taylor's view of the Art Institute of Chicago, *c.* 1892, shows the building under construction. The lake is directly behind the building where landfill has since added acres of parkland and miles of roadway to Chicago's lakefront.

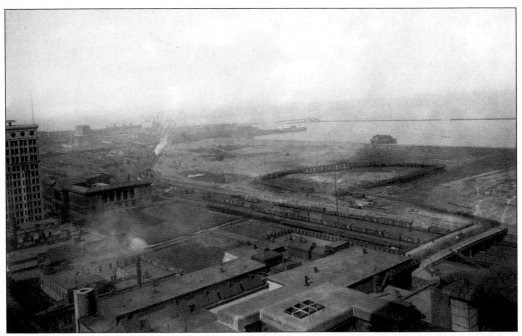

This view, taken from the top of the Auditorium Building in 1907, shows the Art Institute of Chicago surrounded by active train tracks. The building across the avenue from the museum is the Railway Exchange Building (far left), a 17-story office block designed by Daniel Burnham.

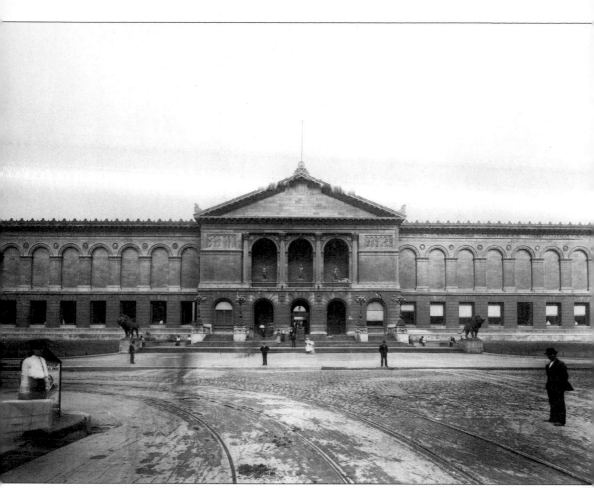

The Allerton Building of the Art Institute of Chicago is the oldest part of the museum's complex. Although the building was envisioned initially as a temporary structure for purposes related to the World's Columbian Exposition, successful fundraising efforts allowed for the construction of a permanent building sited dramatically at the intersection of Michigan Avenue and Adams Street. Completed in 1893, the design by Shepley, Rutan, and Coolege, reflects the Classicism popularized by the world's fair of the same year. A pair of bronze lions, designed by sculptor Edward L. Kemeys and shown in this 1905 image, have flanked the main entrance to the Art Institute of Chicago since 1894.

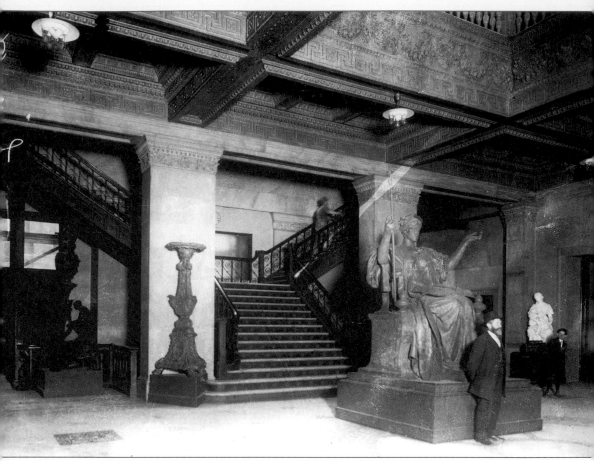

The interior of the Art Institute featured a grand staircase leading to the museum's galleries.

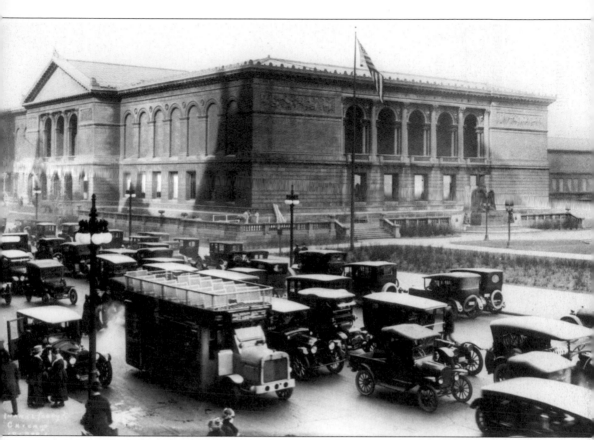

Beyond the fray of heavy traffic, the Art Institute of Chicago and its gardens provide a calm refuge. By 1918, attractively landscaped areas were established around the museum, the first permanent building constructed in Grant Park.

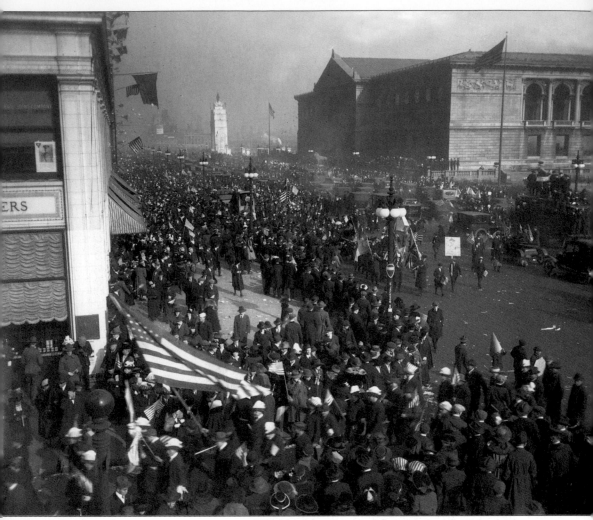

Central Michigan Avenue's impressive buildings and central location made it an appropriate setting for ceremonial occasions. The Art Institute of Chicago frames this image of the Armistice Day Peace Parade in November 1918. A corner of the Railway Exchange Building at Michigan Avenue, and Jackson Boulevard is seen to the left.

Orchestra Hall at 220 South Michigan Avenue was designed by Daniel Burnham. (Courtesy Chicago Architecture Foundation Collection.)

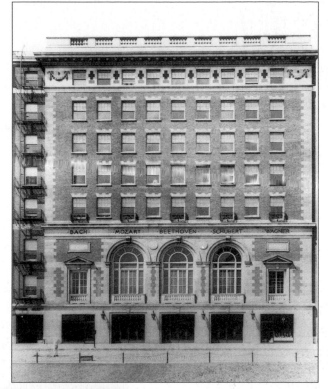

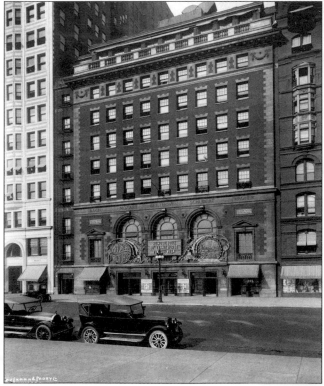

Orchestra Hall firmly established itself as a central institution on Michigan Avenue's culture row. This view shows the hall in 1920.

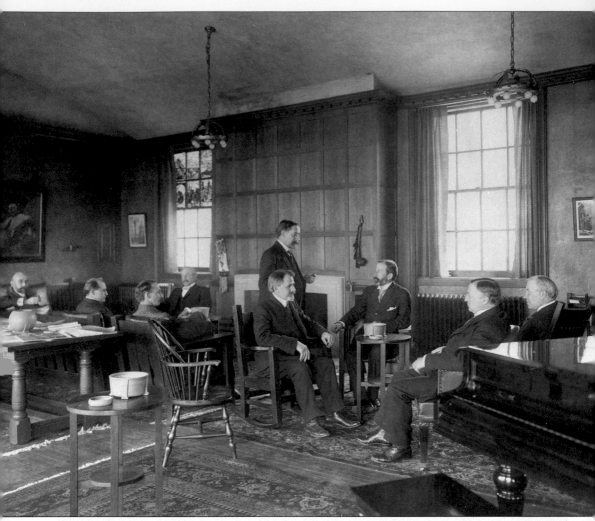

A popular gathering place for architects, the main lounge of the Cliff Dwellers Club, formerly housed atop Orchestra Hall, is shown in this 1915 photograph. The private club, still popular among architects, is now located on the top floor of the Borg-Warner Building, next door.

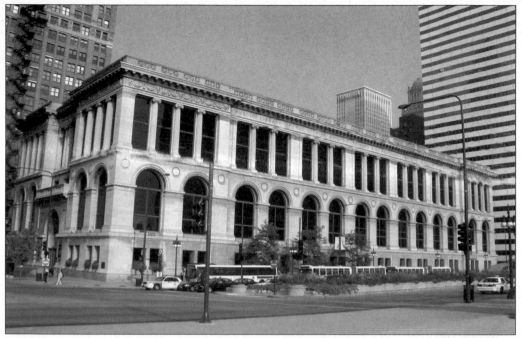

Shepley, Rutan, and Coolidge designed the Chicago Public Library in 1897. The building is now the Chicago Cultural Center. (Courtesy Anne Evans.)

The Chicago Cultural Center, formerly the Chicago Public Library, features mosaic work designed by the Tiffany-trained artist J.L. Holzer. The mosaics, called cosmati work, consist of Favrile glass, colored stone, mother-of-pearl, and gold leaf inlaid in white marble. (Courtesy Anne Evans.)

COMMERCE

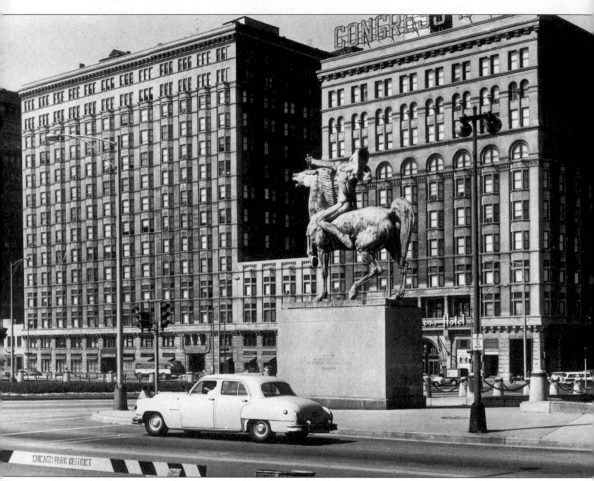

The Congress Hotel, 520 South Michigan Avenue, originally served as an annex of the Auditorium Hotel, built four years earlier immediately to the north. An underground marble-walled corridor below Congress Parkway connected the Congress Hotel to the Auditorium Building. The 400-room Congress Hotel was built in stages. The right half of the structure, including the low, central portion, was designed by Clinton J. Warren and completed in 1893. The large section, left, completed in 1902 and 1907, was designed by Holabird & Roche.

The relatively restrained exterior design of the hotel merely hints at the elaborate interiors that originally awaited guests inside. Most of these lavishly designed spaces, including a skylit, two-story, mural-adorned Pompeian Room, no longer exist. Most were removed or remodeled when the United States Army occupied the hotel during World War II.

One of two nude Native American warrior sculptures, *Bowman* and *Spearman* that stand before Grant Park is shown in the foreground. The work of sculptor Ivan Mestrovic (1883–1962), they were cast in his studio in Yugoslavia. Each weighing 27,000 pounds, the sculptures were unveiled in their current location in 1928.

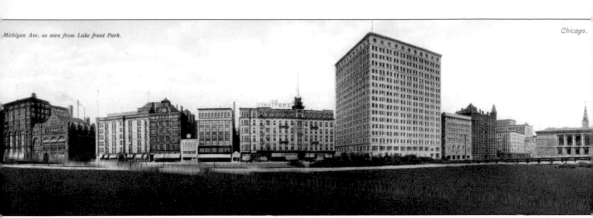

A historic postcard shows the buildings along the Avenue between Congress Parkway and Adams Street. The Auditorium Building stands to the far left and the tallest building shown is the Railway Exchange Building. The Art Institute of Chicago appears to the far right.

The Railway Exchange Building, completed in 1904, illustrates the commercial power of the railroad industry and its ability to erect elaborate administrative headquarters in prime downtown locations. Originally home to the Santa Fe Railway Company, as well as the Milwaukee and the Alton, the gleaming white, 17-story, terra cotta-clad beauty was intended to contrast dramatically to the soot-sullied buildings in other parts of the Loop. Designed by Frederick Dinkelberg of D.H. Burnham and Company, the Railway Exchange Building is generously adorned with classical ornamentation. One of Daniel Burnham's most talented designers, Dinkelberg is credited for the design of the People's Gas Building, one block to the south, and New York's Flatiron Building.

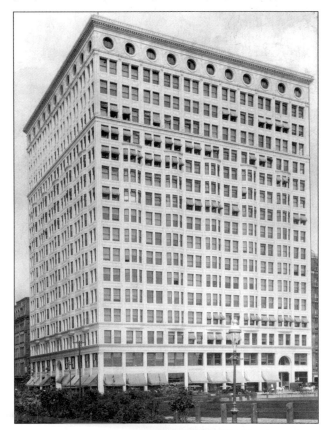

Soon after the building's completion, Burnham, a major investor in the building's development company, moved his successful architectural practice to the 14th floor of the Railway Exchange Building. In these offices, Burnham's famous 1909 Plan of Chicago was produced.

Known today as the Santa Fe Building, the structure underwent an extensive renovation, completed in the 1980s, that retained and restored much of its original splendor and elegance. Although the building no longer serves as headquarters for railroad companies, or for Daniel Burnham's practice, its list of tenants includes several prominent architecture firms as well as the Chicago Architecture Foundation.

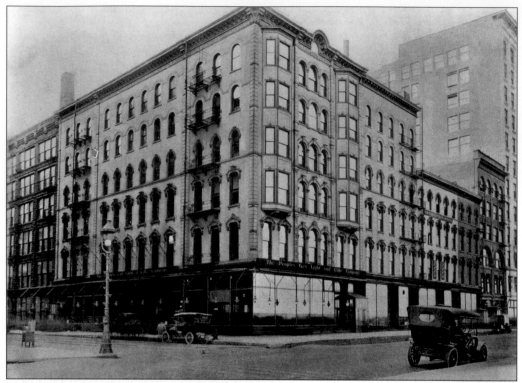

The Gas Building stood at the corner of Michigan Avenue and Adams Street. (Courtesy Chicago Architecture Foundation.)

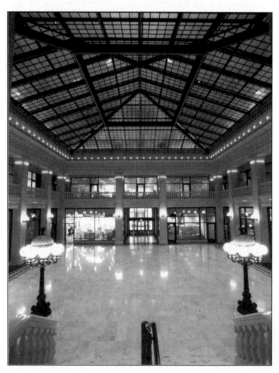

The Railway Exchange Building (1904, D.H. Burnham and Company) is a commercial office building built around a central light court. A two-story glass-covered court at the base of the light well is dominated by a grand staircase. (Courtesy Anne Evans.)

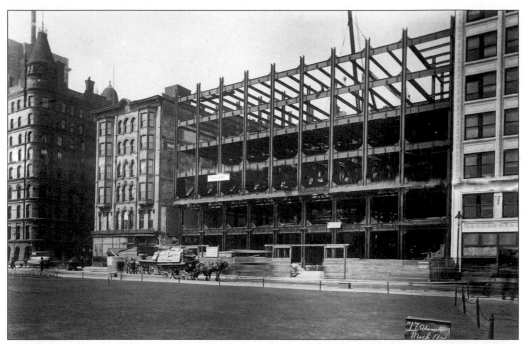

The People's Gas Building was under construction in May 1909. Although the building will be clad in traditional granite and terra cotta, the building's core is a modern metal frame. The design of the People's Gas Building is attributed to Frederick Dinkelberg of Daniel Burnham's D.H. Burnham and Company.

The McCormick Building at 332 South Michigan Avenue, left, was designed by Holabird & Roche, and constructed in stages completed in 1912.

The building was commissioned by Robert Hall McCormick, on behalf of his father, Leaner McCormick, who with his brother Cyrus had run the huge McCormick Harvesting Machine Company.

Strong in overall massing, but relatively uncomplicated in design, the McCormick Building inspired one critic to declare in 1910, "If there is beauty in simplicity, here it is."

43

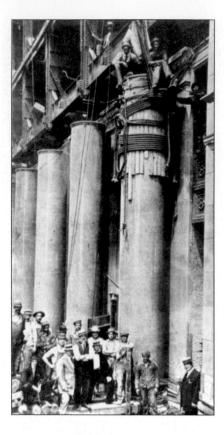

The columns at the front of the People's Gas Building are installed. (Courtesy Chicago Architecture Foundation.)

The Straus Building, now the Britannica Center, was designed by Graham, Anderson, Probst, and White, architects of Chicago's Wrigley Building and Merchandise Mart. Completed in 1924 at 310 South Michigan Avenue, the Straus Building originally housed the banking floors of the investment firm S.W. Straus and Company. The classically inspired building is topped by a pyramidal roof capped with glazed beehive, symbolizing thrift and industry.

The setback skyscraper design of the Straus Building reflects the 1923 zoning ordinance that allowed for buildings taller than 260 feet, provided the space above the 260-foot mark did not exceed 25 percent of the building and was set back from the property lines.

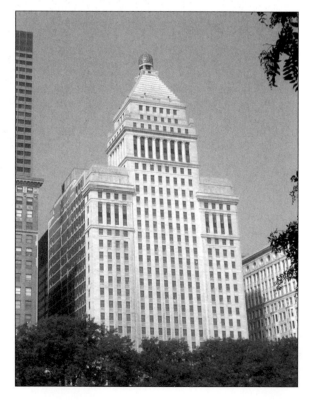

44

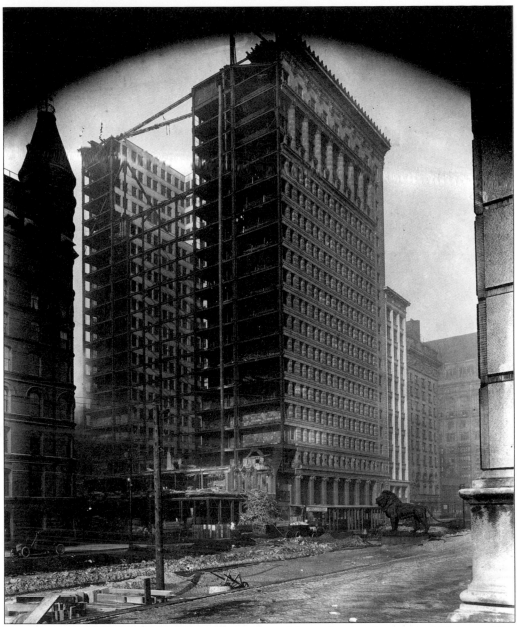
Construction of the People's Gas Building, viewed from the Art Institute of Chicago. The building's arrangement of office space constructed around a central light well is evident in this historic image.

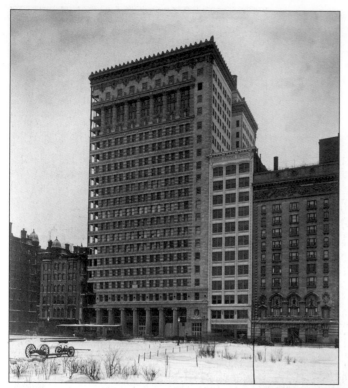

To the right of the People's Gas Building, shown again under construction, are the slender Municipal Courts Building (1906, Jenney, Mundie & Jensen), also known as the Lake View Building, and the Illinois Athletic Club (1908, Barnett, Hayes and Barnett). Additional upper stories would later be added to both of these structures, attesting to the area's growing commercial activity.

The Illinois Athletic Club at 112 South Michigan Avenue was designed by Barnett, Haynes & Barnett. The classically inspired building is crowned with a frieze, by Leon Harmant, showing Zeus overseeing athletic events. Designed in the Beaux Arts Style, the building was expanded upward in 1985 with the sympathetic addition of six floors.

In 1993, adding to the growing presence of educational institutions along Central Michigan Avenue, the School of the Art Institute of Chicago acquired the building for use as dormitory, classroom, studio, and event space. The building features a restored, two-story ballroom above the entrance. (Courtesy Chicago Architecture Foundation.)

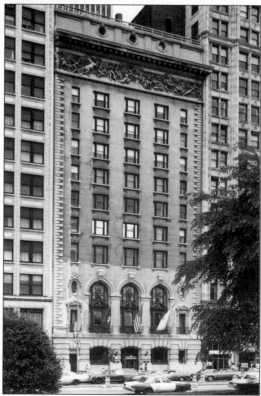

46

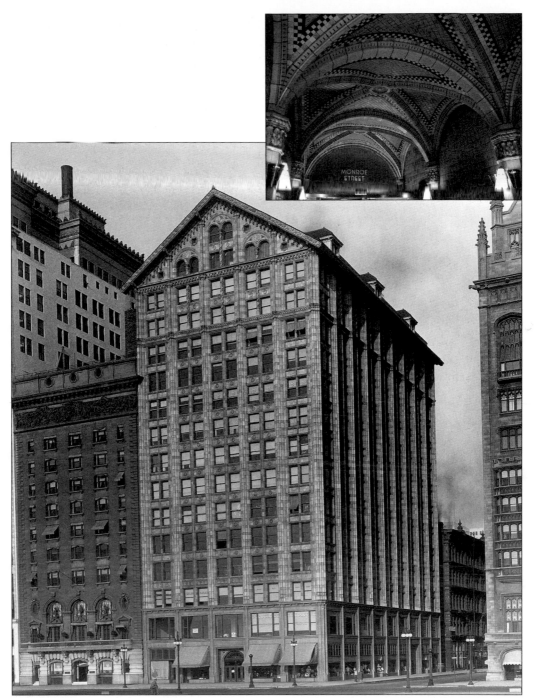

The Romanesque-inspired design of the Monroe Building at 104 South Michigan Avenue (1912, Holabird & Roche) features a distinctive gabled roof and arched upper-story windows. The building's Gothic-style vaulted lobby is clad in a multi-colored arrangement of Rookwood tile. Associated with the Arts and Crafts movement, the Cincinnati-based Rookwood pottery firm and studio was founded in 1880. The Monroe Building lobby is considered one of the finest examples of Rookwood detailing in the country. (Inset photo courtesy of Anne Evans.)

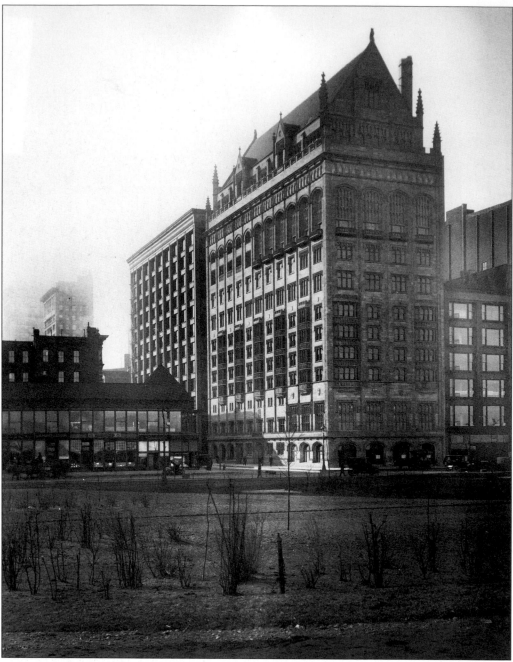

The University Club, 76 E. Monroe, designed by Holabird & Roche, was constructed in 1908. Its Gothic-style detailing links it in tone to the Collegiate Gothic architecture of the University of Chicago's Hyde Park campus.

The University Club's prominent gothic spires, tracery windows, and crenelated parapet add to the medieval character of the design. Arched storefront openings carry the building's Gothic qualities down to street level where they are enjoyed by all who walk by.

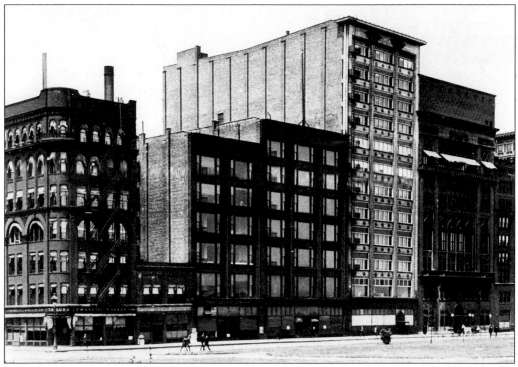

The Gage Group, center, includes 30, 24, and 18 South Michigan Avenue. Holabird & Roche were the architects of these steel-frame loft buildings. Clad in red brick, the Edson Keith and Theodore Asher Buildings at 30 and 24 South Michigan Avenue feature large Chicago windows that let in abundant natural light. Louis Sullivan designed the façade of 18 South Michigan Avenue. Sheathed in buff terra cotta, the design is especially notable for the two gigantic piers crowned with Sullivan's signature naturalistic ornament.

Chicago windows define the facades of the Gage Group buildings at 30 and 24 South Michigan Avenue. Each window is composed of a wide, fixed pane flanked by a pair of double-hung sash windows. (Courtesy Zurich Esposito.)

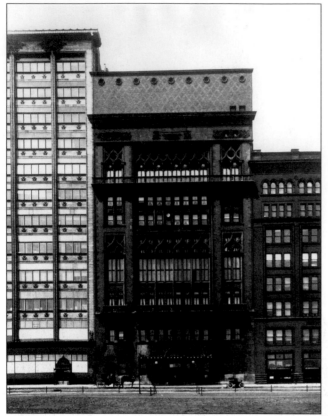

The Chicago Athletic Association stands at 12 South Michigan Avenue, next door to the Gage Group. Designed by Henry Ives Cobb in a Venetian Gothic style, it was built in 1893.

For many years after its construction in 1899, the Montgomery Ward Building, designed by Richard E. Schmidt at 6 North Michigan was Chicago's tallest building and an observation deck made it a particularly popular tourist destination. But while tourists were enjoying the building's outdoor pleasures, what went on inside was all about business. The Montgomery Ward Building served a dual purpose as both administrative headquarters and catalog warehouse for Montgomery Ward and Company. With commercial activity so intense, it is no surprise that the building earned the nickname the "Busy Bee Hive."

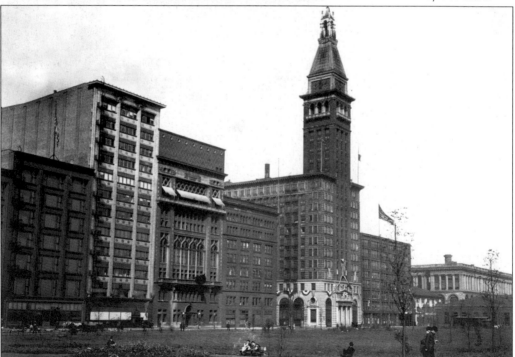

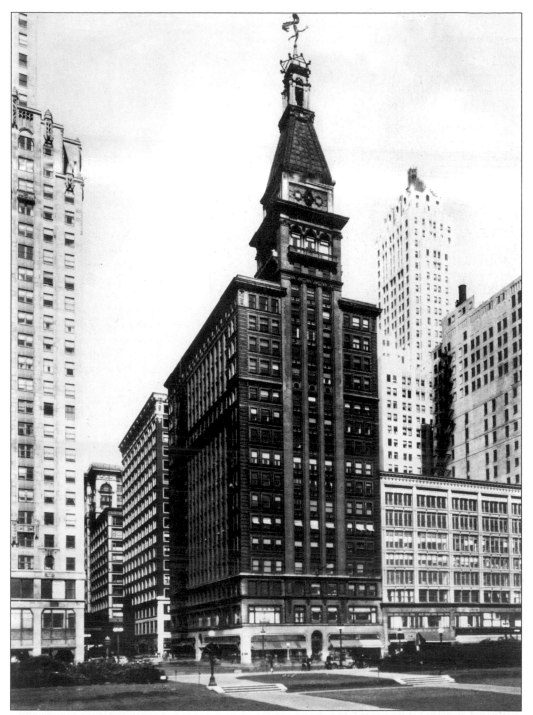

In 1923 Holabird & Roche expanded the Montgomery Ward Building (known today as 6 North Michigan Avenue), wrapping the tower with four additional upper stories. The street-level façade was also remodeled at this time. The pyramidal roof section of the tower was removed in 1947. The current renovation and conversion of the building to condominium residences calls for some form of its resurrection.

The top of the Montgomery Ward Building included a tempietto topped by a gilded weathervane featuring a female figure. The sculpture was entitled, "Progress Lighting the Way for Commerce." (Courtesy Chicago Architecture Foundation.)

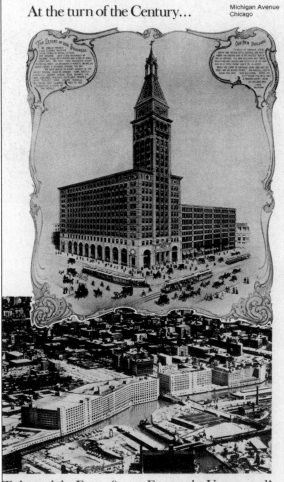

An advertisement shows the relationship between the Montgomery Ward Building and the Ward warehouse, an important one for a famous mail order house. The modern warehouse, constructed by Richard E. Schmidt, Garden, & Martin, was built along the Chicago River between 1906 and 1908. (Courtesy Chicago Architecture Foundation.)

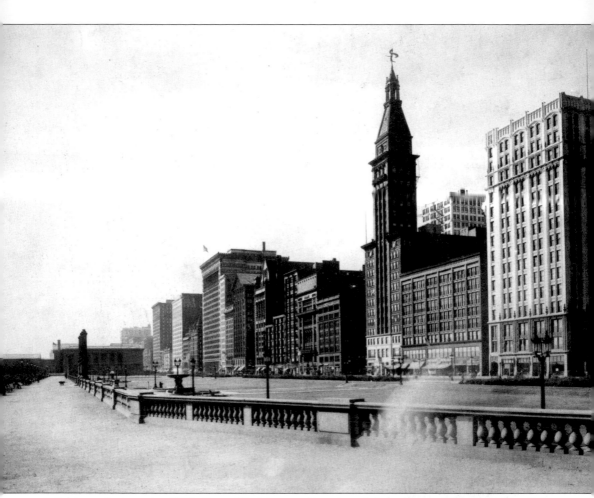

Michigan Avenue in 1917, from Washington Street to Adams Street. To the right of the Montgomery Ward Building stands the Smith Gaylord & Cross Building at 20 North Michigan Avenue. Designed by Beers, Clay, & Dutton and completed in 1885, it is the oldest remaining structure along Central Michigan Avenue. Originally a two-story commercial warehouse, the building was expanded to eight stories by Montgomery Ward and Company who later used it for their catalog operation. In the mid-1980s, Nagle Hartray & Associates renovated the structure, converting it to a modern office building.

The Michigan Boulevard Building, far right, stands at the corner of Michigan Avenue and Adams Street. Completed in 1904, the neo-Gothic building clad in ivory-colored terracotta was designed by Jarvis Hunt, nephew of the renowned New York architect Richard Morris Hunt. The building's first 15 stories were completed in 1914. The upper 5 stories were added in 1923.

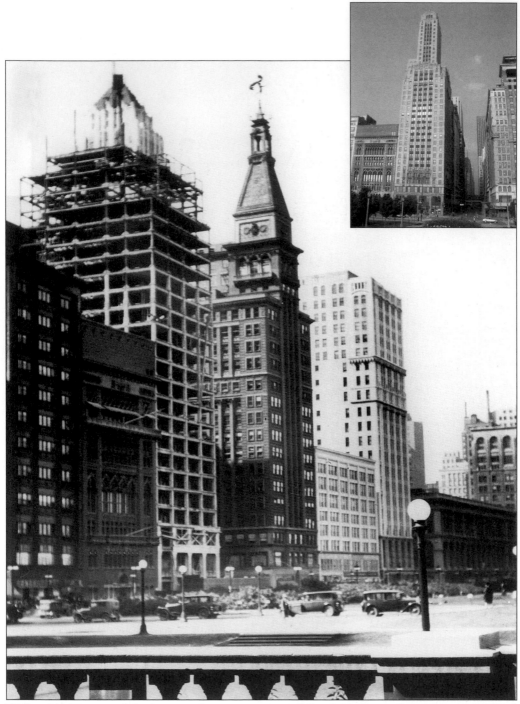

Willoughby Tower, at left, shown under construction at 8 South Michigan Avenue, was completed in 1929. The Gothic-inspired skyscraper was designed by Samuel N. Crowen & Associates. At 410 feet in height, it is among the tallest buildings on Michigan Avenue that overlook Grant Park. The building's tower, set back on all four sides, gives the design a decidedly vertical emphasis. The inset shows the building as it looks today.

Three

THE EVOLUTION

OF THE LAKEFRONT

1890–1930

Much of Central Michigan Avenue's character derives from its expansive green spaces framing Lake Michigan. The development of the lakefront dates to the late nineteenth century. Many progressive thinkers believed that creating green areas within the industrial city would provide breathing room and necessary space for leisure activities.

The area along the lakefront, called Lake Park since 1847, was shaped by sandbars, landfill, and debris from the Chicago Fire of 1871. Although Lake Park was established legally in 1861, for many years it housed shacks, staging areas for refuse removal, and two federal armories.

In 1890 Aaron Montgomery Ward, whose mail-order business was headquartered at Michigan Avenue near Madison Street, brought a lawsuit against the City of Chicago to clean up the area. Preparing for the World's Columbian Exposition of 1893 furthered plans to improve Lake Park. The construction of the Art Institute of Chicago's new building in 1893 at Michigan Avenue and Adams Street also helped spur improvement efforts.

In 1901 the South Park Commission renamed the site Grant Park. The formal, French-inspired layout of Grant Park was executed over the years by many architects. The Olmsted Brothers' 1907 plan envisioned the park along the lines of the gardens at Versailles. Daniel Burnham's 1909 Plan of Chicago helped establish a vision of the area in the Beaux-Arts manner. Edward Bennett, who co-authored Burnham's 1909 plan, began a long association with the South Park Commission in 1915. The commission accepted a comprehensive park plan based on Beaux-Arts principles. By the 1930s, Grant Park's development ground to a halt as the Great Depression gripped the country.

In the late nineteenth century, parkland along the lakefront was enhanced. The Illinois Tunnel Company dumped excavated earth into the lake. Portions of the park from Randolph Street south and east of the Illinois Central Railroad tracks were created in this manner.

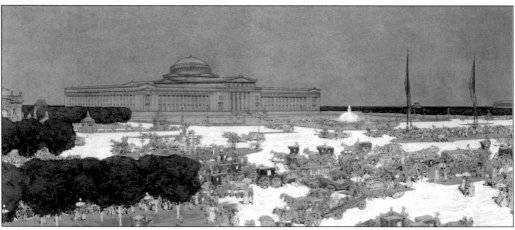

The architect Daniel Burnham's 1909 Plan of Chicago proposed the conversion of Central Michigan into a grand boulevard in the European manner. Jules Guerin's rendering of this idea, seen here, looks east from the corner of Jackson Boulevard across a broad plaza toward the proposed Field Museum of Natural History in Grant Park.

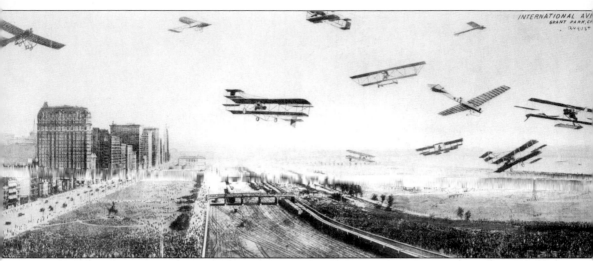

An International Aviation Meet took place in Grant Park in 1914.

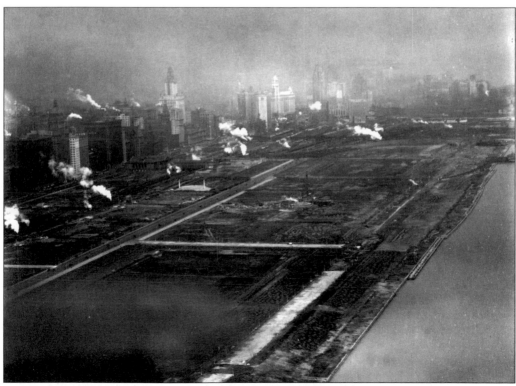

A 1920 aerial photograph shows the construction of Lake Shore Drive and the lakefront. The view shows the buildings along Central Michigan Avenue from Jackson Boulevard to North Michigan Avenue.

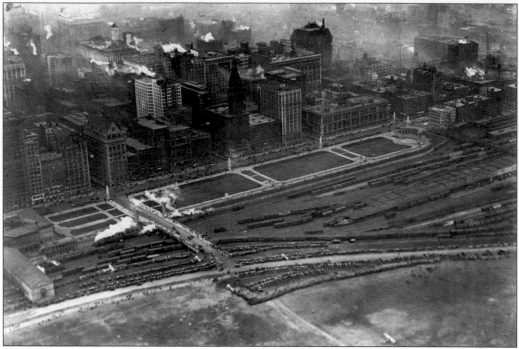

A 1919 aerial photograph shows Grant Park at the foot of the Michigan Avenue streetwall between Monroe Street and Randolph Street. The historic peristyle, a semicircular grouping of columns, is situated at the northern end of the park, right.

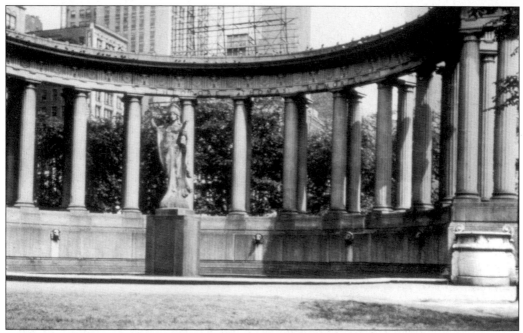

The historic peristyle, designed by Edward Bennett in 1917, was demolished in 1954 for the construction of underground parking. A near-replica, the Millennium Monument in Wrigley Square, was recently installed in its original location as part of Millennium Park.

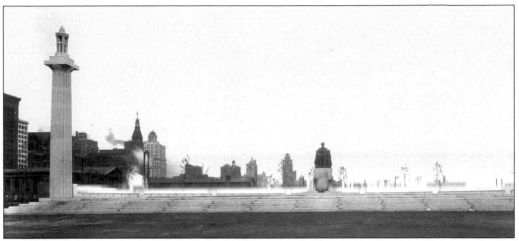

The Seated Lincoln presides over a Grant Park garden, adjacent to South Michigan Avenue. The sculpture is one of two likenesses of President Lincoln in Chicago created by renowned sculptor Augustus Saint-Gaudens (1848–1907). Philanthropist John Crerar (1827–1889) left a bequest of $100,000 in his will for the piece, which took Saint-Gaudens 12 years to complete. The sculpture was originally intended to be part of a Court of the Presidents. This monument, installed in 1926, was the only statue placed in the exedra designed by McKim, Mead, and White.

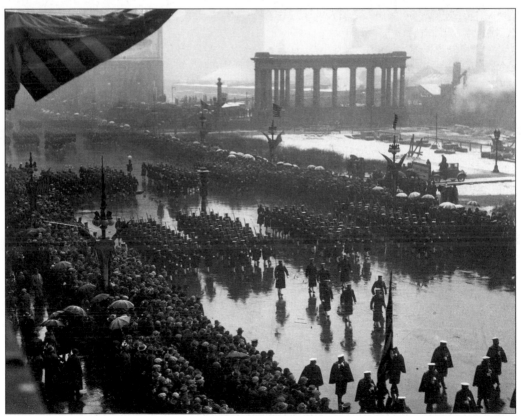

Designed by Chicago architect Edward Bennett and built in 1917, the historic peristyle forms an imposing backdrop to the 1927 Army-Navy Games' Cadet Parade on Michigan Avenue.

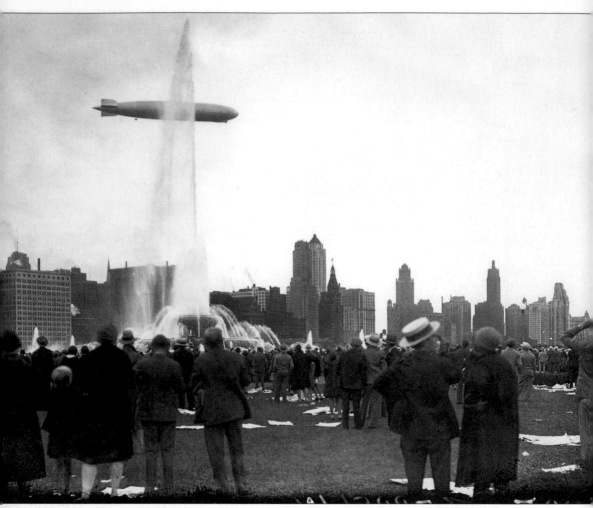

Crowds gather in Grant Park near Buckingham Fountain to watch the Graf Zeppelin fly over Central Michigan Avenue.

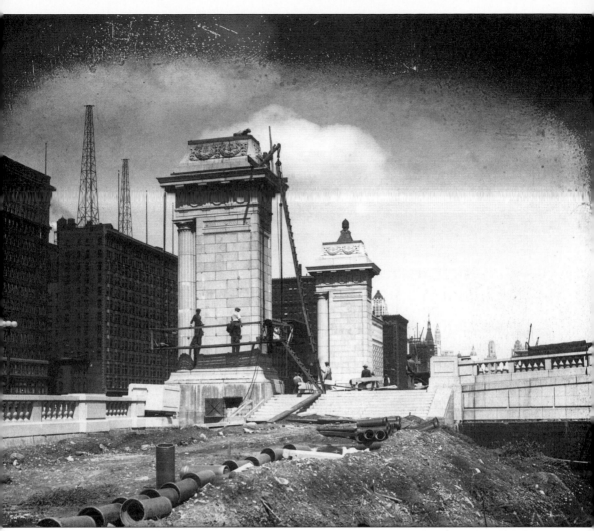

The Beaux-Arts grand plaza at Michigan Avenue and Congress Parkway is shown under construction in 1928. The design and construction of the plaza took place under the supervision of Edward Bennett. Bennett was the consulting architect to the Chicago Plan Commission and the architect retained by the South park Commission to oversee Grant Park. Bennett's balustraded railings and columned piers provide European-inspired monumental beauty to this expansive public space on the east side of Michigan Avenue.

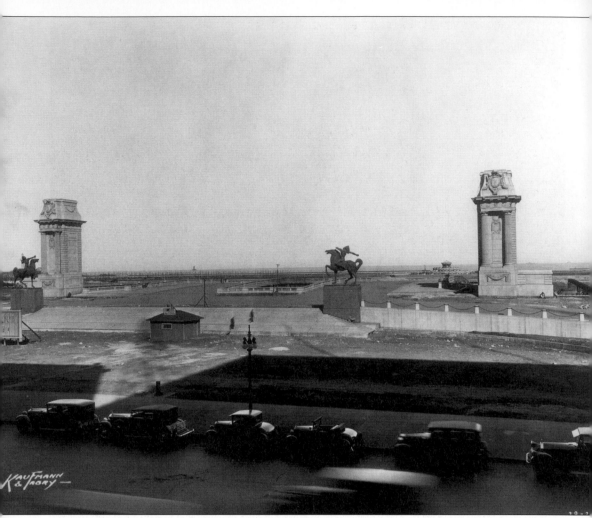

The grand plaza, leading to Buckingham Fountain, featured an elegant staircase and gigantic piers. Statues of Native Americans on horseback, *The Spearman* and *The Bowman*, by Ivan Mestrovic, flank the steps.

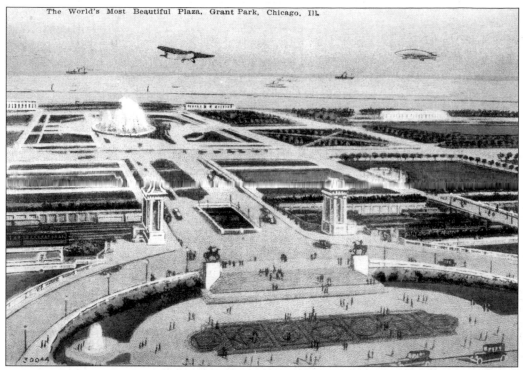

A souvenir image shows Congress Plaza as part of a striking vista through Grant Park to Lake Michigan. In 1955, Congress Parkway was widened and extended through the park, destroying the central stairway and altering much of the plaza.

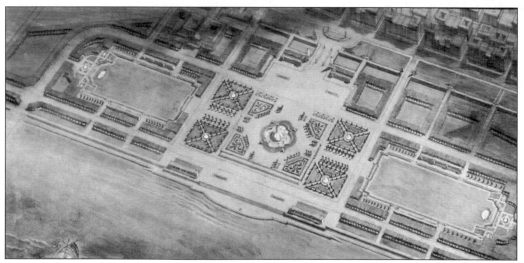

An aerial view shows Grant Park laid out in the Beaux-Arts manner, as Edward Bennett intended. (Courtesy Chicago Park District.)

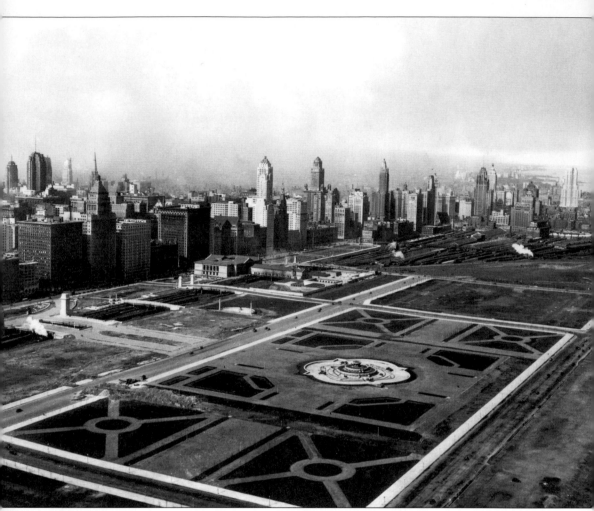

A 1929 view shows Congress Plaza, Buckingham Fountain, the Lincoln statue, and the historic peristyle, and conveys the formal layout of the grounds in Grant Park.

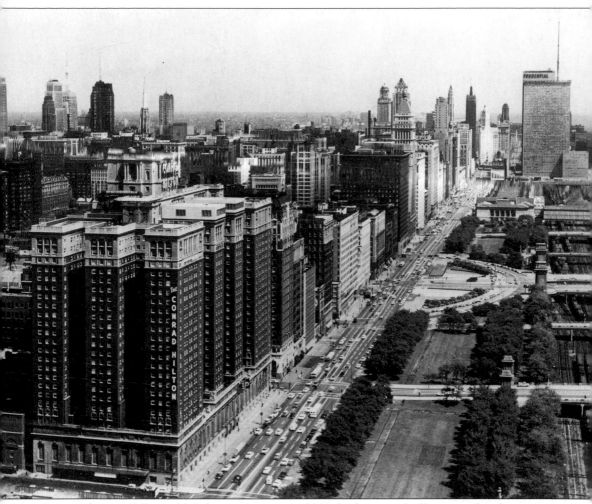

An aerial view of Central Michigan Avenue, c. 1960, looking north illustrates the changes to Congress Plaza, center right. The Prudential building, at the time Chicago's tallest building, dominates the distant skyline, right.

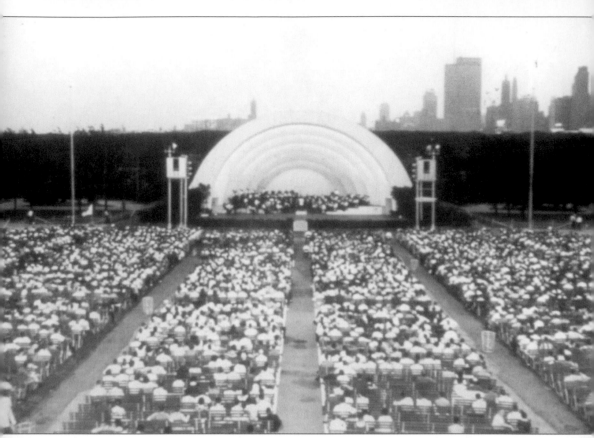

Crowds gather at a historic, now-demolished bandshell in Grant park to hear a concert. (Courtesy Chicago Park District.)

Four

THE AVENUE DURING
THE ROARING TWENTIES

The opening of the Michigan Avenue Bridge in 1920 helped shift the focus of development to the north and south banks of the Chicago River. The north bank saw the construction of the Wrigley Building and the Tribune Tower. These tall buildings frame the view of North Michigan Avenue. On the south side of the river, development roared ahead with the construction of neoclassical and Art Deco towers.

Two tall towers frame the view of South Michigan Avenue. On the west side of the street stands the neoclassical London Guarantee & Accident Building. Designed by Alfred S. Alschuler in 1923, the building's shape echoes the bend in the Chicago River. To the east stands 333 North Michigan Avenue, an Art Deco skyscraper designed in 1928 by Holabird & Root.

Further south, at 230 North Michigan Avenue, the Art Deco Carbide & Carbon Building presides over a handful of low and mid-rise structures. The building rises from a polished black marble base trimmed in bronze. The dark green terra cotta clad structure rises to a fifty-foot tower decorated with gold leaf.

Continuing down the avenue, the area south of Congress Parkway saw the construction of one of the world's largest luxury hotels, the Stevens Hotel (now Chicago Hilton & Towers.). Designed by Holabird & Roche, the hotel was completed in 1927. By 1930, construction on the avenue ceased, and development of the area remained relatively stagnant until after World War II.

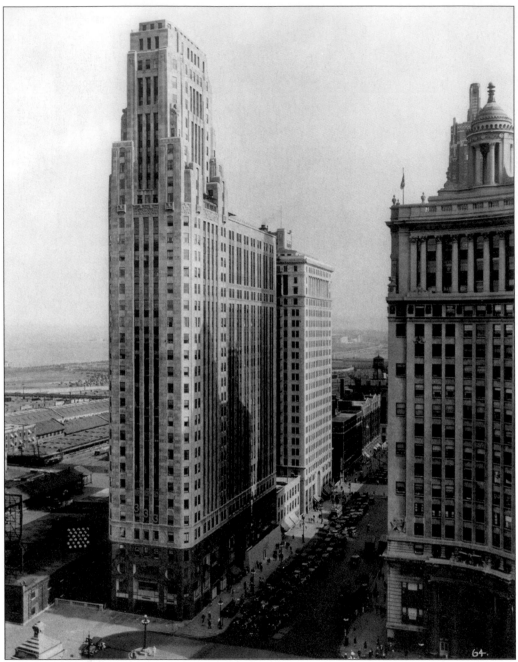

Holabird & Roche's Art Deco design for 333 North Michigan Avenue, left, was constructed in 1928. The neoclassical London Accident & Guarantee Building, designed by Alfred S. Alshuler, was completed five years earlier. This pair of notable skyscrapers creates an impressive gateway to Michigan Avenue south of the Chicago River.

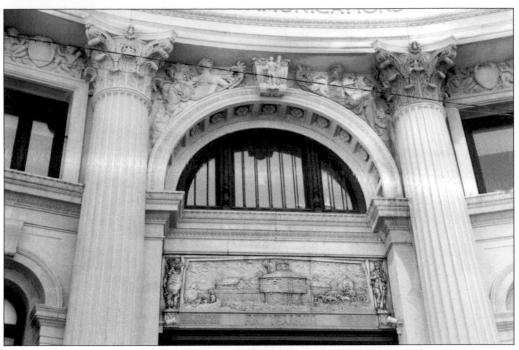

An inscription over the entrance states that the London Guarantee & Accident Building was constructed on the site of Fort Dearborn. (Courtesy Anne Evans.)

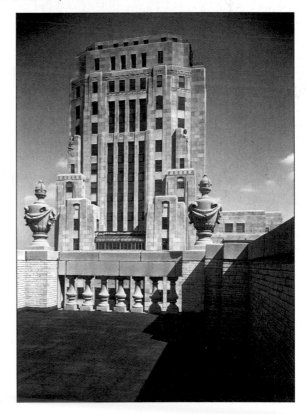

The Art Deco 333 North Michigan Avenue, viewed between the urns atop the London Guarantee & Accident Building roof, features pronounced vertical piers, recessed spandrel panels beneath windows, and many setbacks at the building's attenuated crown. Combined, these characteristics, typical of Art Deco buildings, impart soaring verticality to Holabird & Roche's design.

The area between Randolph Street and the Chicago River also included low- and mid-rise buildings with brick and limestone facades such as the Lake-Michigan Building at 180 North Michigan Avenue. The structure, shown in a 1937 image, was designed by Jarvis Hunt in 1914.

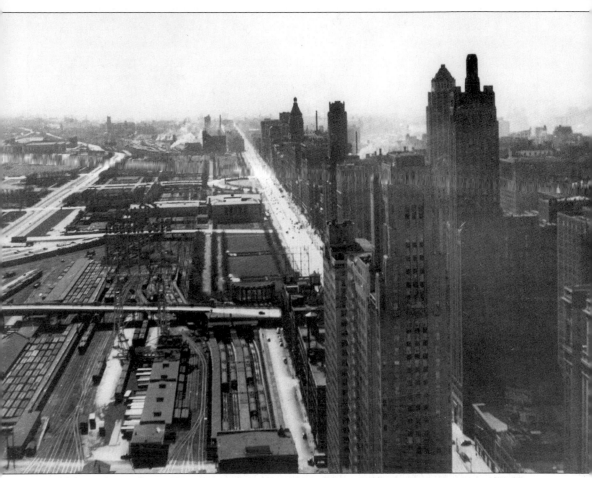

Viewed from the Tribune Tower in 1946, Central Michigan Avenue, flanked on one side by a magnificent streetwall of commercial buildings, stretches into the horizon, overlooking a network of railways and lakefront parks to the east (left).

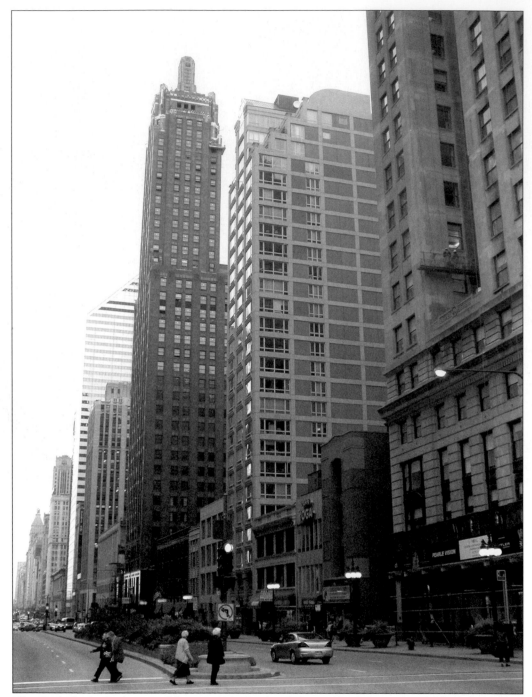

The Carbide & Carbon Building at 230 North Michigan Avenue is sheathed in dark green terracotta. It upper-story setback tower is beautifully trimmed with gold leaf. Burnham Brothers' 1929 Art Deco office tower is shown during an adaptive reuse renovation designed by Lucien Lagrange and Associates. The building will re-open as a hotel. (Courtesy Anne Evans.)

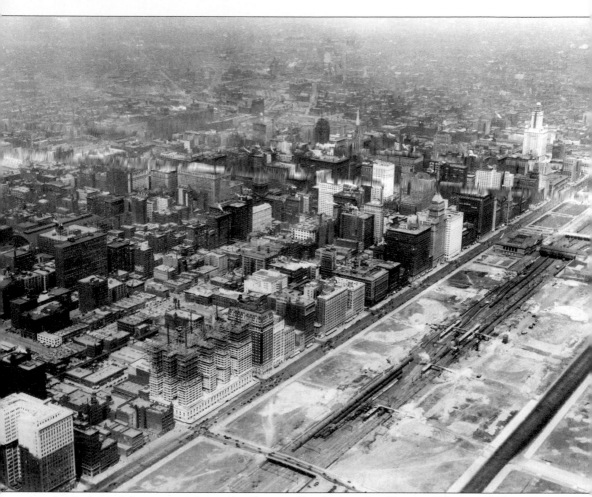

An aerial view of the avenue shows the Stevens Hotel, now the Chicago Hilton and Towers Hotel, under construction in the 1920s. At the time, much of Grant Park was undeveloped land criss-crossed by active train tracks.

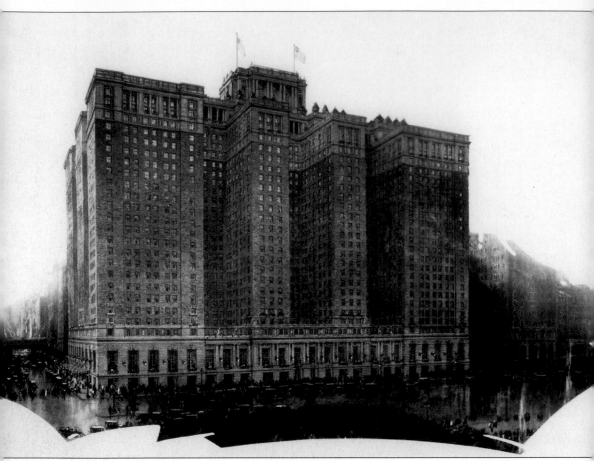

A 1926 image of the Stevens Hotel, designed by Holabird and Roche, shows the French-inspired structure. Completed in 1927, the 25-story building was the world's largest and most opulent hotel.

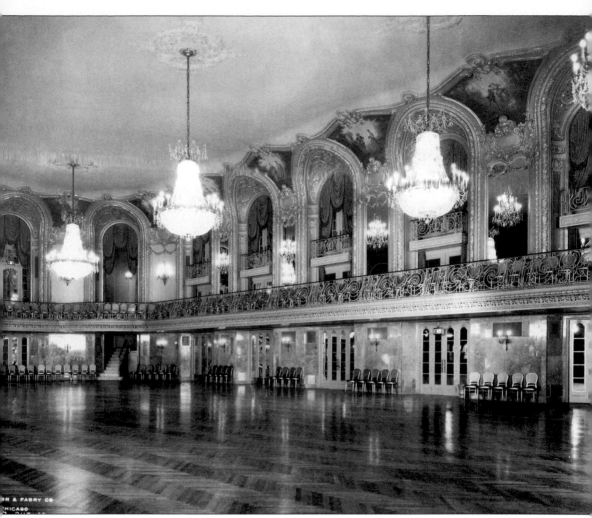

The Stevens Hotel includes many lavish interiors, such as this Louis XVI-style ballroom.

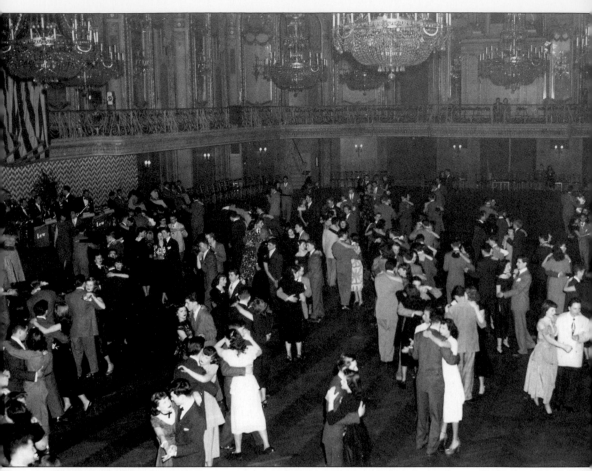

The hotel ballroom, as seen here in a *c.* 1948 photograph, provides a dazzling setting for dancing.

Five

POST-WAR
DEVELOPMENT
1945–1970

After World War II, construction along the avenue resumed. The 41-story Prudential Building, constructed at the corner of Randolph Street and Michigan Avenue, helped spur development throughout the downtown area. Designed by the architects Naess & Murphy, the limestone-clad building included a relief sculpture of the Rock of Gibraltar, Prudential's trademark, by Alfonso Iannelli. At the time of its completion in 1955, the Prudential was the tallest tower in the city and the world's fifth-tallest building. This project was also the first along the avenue to be constructed using air rights over the Illinois Central Railroad yards.

The Prudential Building changed the character of construction on the avenue, and led the way for other modern skyscrapers. In the 1960s Illinois Center, a gigantic commercial complex including office buildings, shops, apartments, and hotels, was planned for a site along the avenue between the Chicago River and Lake Street. The enormously profitable development featured steel-and-glass towers designed by the internationally famous modern architect Ludwig Mies van der Rohe.

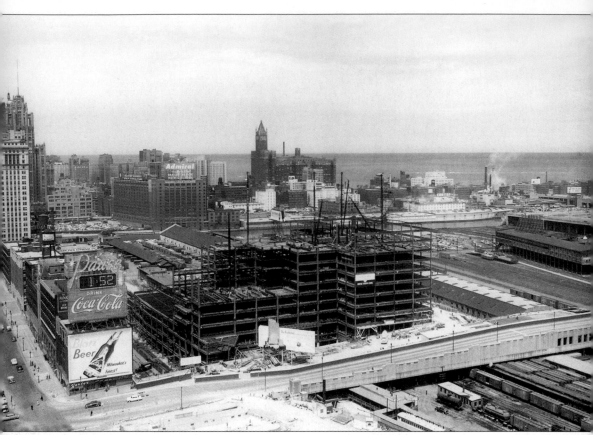

In 1954 the Prudential Building was under construction at the corner of Michigan Avenue and Randolph Street. The building was Chicago's tallest skyscraper at the time of its construction.

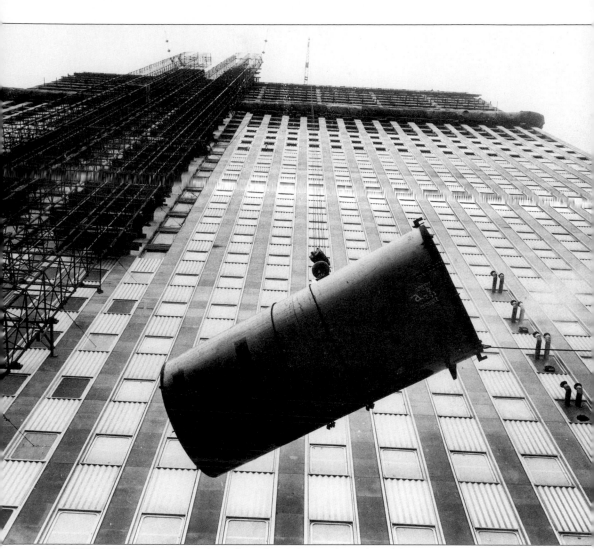

The WGN-TV mast is hoisted up the side of the Prudential Building.

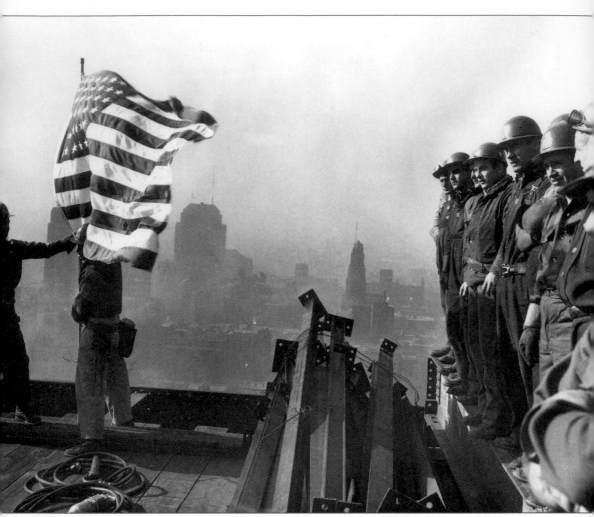

The flag is placed on the Prudential Building at the topping off in November 1954.

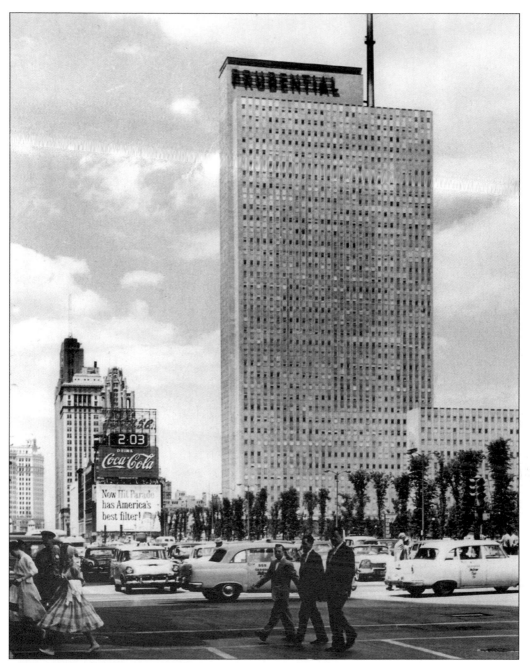

The Prudential Building at 130 East Randolph Street presides over traffic on Michigan Avenue in 1957. The modern, slab-like quality of Naess & Murphy's 1955 design made it a distinctive, contemporary addition to the avenue. The Prudential Building set the tone for the future development of skyscrapers along Michigan Avenue and East Randolph Street. The parkland at Michigan Avenue and Randolph Street would eventually become Millennium Park.

Commerce and transportation meet at the corner of Michigan Avenue and Randolph Street in 1962.

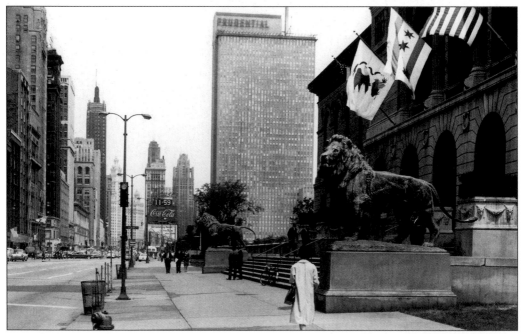

A stroll down Michigan Avenue in 1960 shows the grandeur of the Art Institute framed by a row of vintage and modern skyscrapers. The Carbide & Carbon Building, the Wrigley Building, the Tribune Tower, and the Prudential Building are clearly visible in the distance.

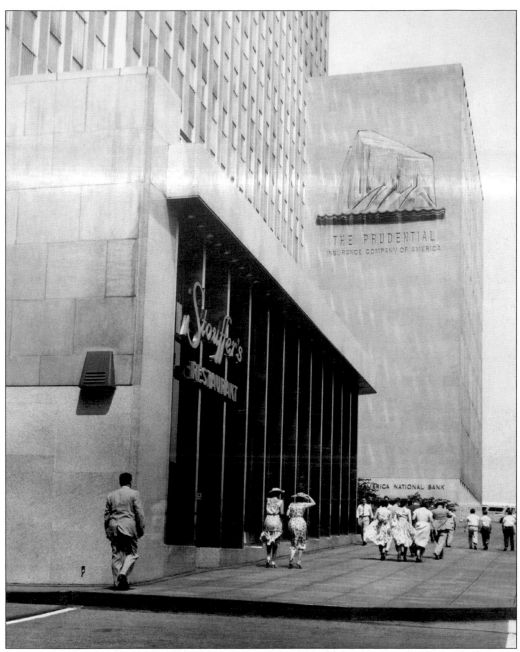

The approach to the Prudential Building along Randolph Street in 1958 shows the pedestrian experience of restaurants and the tall office tower. The Prudential's signature Rock of Gibraltar is represented as a relief sculpture by Alfonso Iannelli.

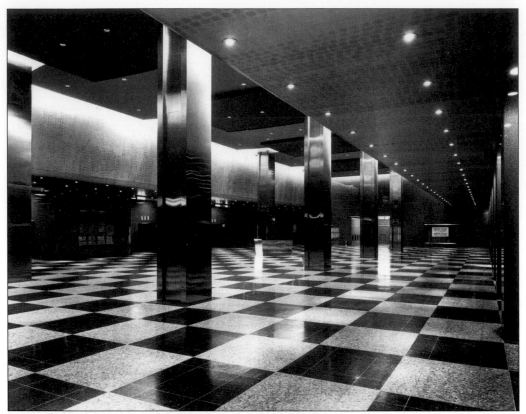

The lobby of the Prudential Building features terrazzo floors and gleaming steel piers.

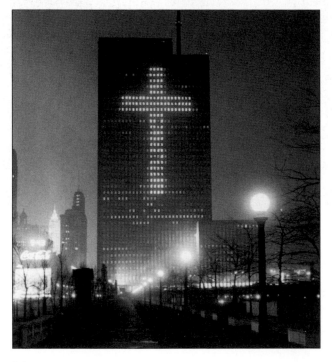

The Prudential Building appears in a 1962 night view in Christmas dress.

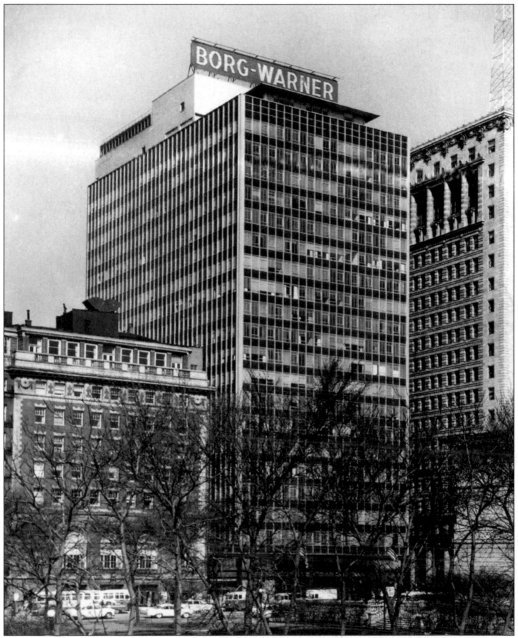

The Borg-Warner Building at the corner of Adams Street and Michigan Avenue, directly across from the Art Institute of Chicago, is representative of late-1950 skyscraper design in the area. The Borg-Warner Building replaced the Pullman Building, an 1884 luxury apartment and office building designed by Solon S. Beman that was demolished in 1956. The 22-story Borg-Warner was completed two years later for the machine tool manufacturer. Designed by the Swiss-born modernist architect William Edmond Lescaze with A. Epstein & Sons, it features a vibrant curtain wall of glass and blue-enameled metal.

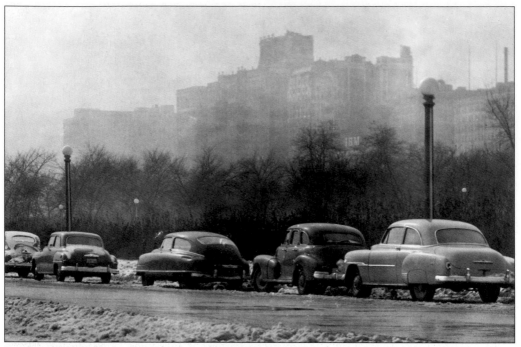

Further down the avenue, the Blackstone Hotel and the Conrad Hilton appear against a snowy gray sky. (Courtesy Chicago Architecture Foundation.)

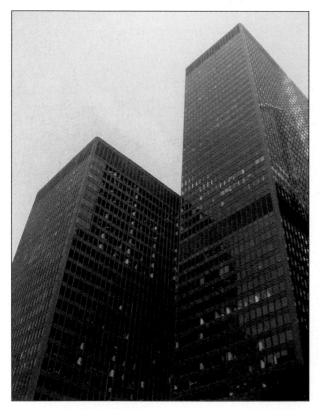

In 1967 Ludwig Mies van der Rohe, the famous German-born modern architect, began a master plan for Illinois Center. The project included office buildings, shops, apartments, and hotels on a parcel of land bounded by the Chicago River, North Lake Shore Drive, North Michigan Avenue, and East Lake Street. This photograph shows Two Illinois Center, one of the buildings that face Michigan Avenue from this large mixed-use development. (Courtesy Anne Evans.)

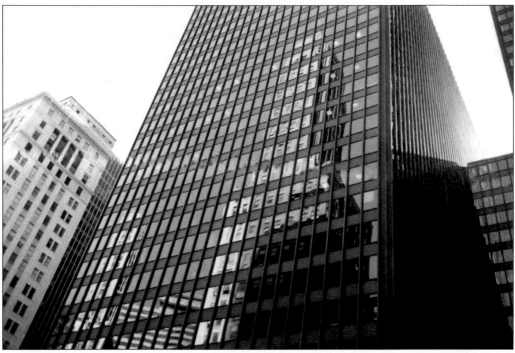

The image of the Art Deco Carbide & Carbon Building is reflected on the glassy surface of Two Illinois Center. The structure is a Miesian steel-and-glass box with a curtain wall of bronze-tinted glass. (Courtesy Anne Evans.)

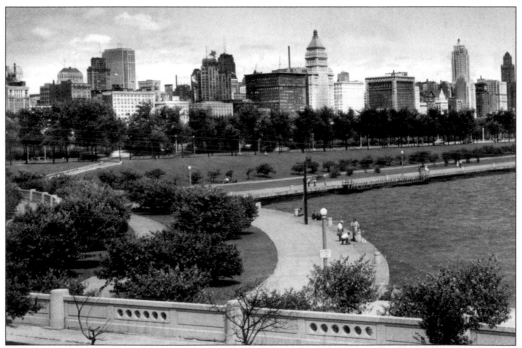

Viewed from the steps of the John G. Shedd Aquarium in 1949, Central Michigan Avenue's streetwall of buildings provides a majestic backdrop for Grant Park.

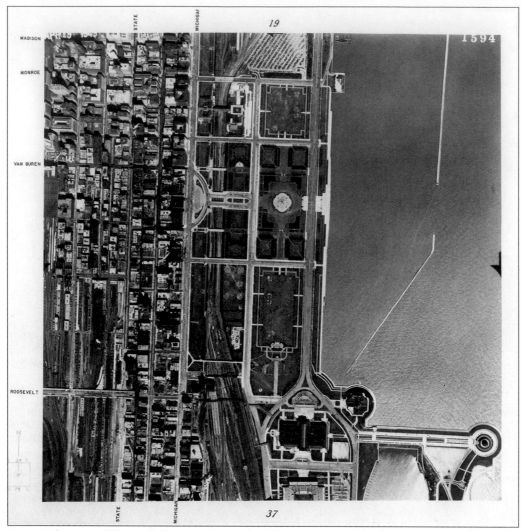

An aerial view of Grant Park taken from the Chicago Transit Authority in 1949 shows the potential for a link between Grant Park and the museums to the south, including the Field Museum, the Adler Planetarium, and the Shedd Aquarium.

Six

THE CONTEMPORARY AVENUE

At the dawn of the 21st century, Central Michigan Avenue serves as a microcosm for implementing several of the city's development priorities: expanding residency in the city's downtown core through condominium development, preserving Chicago's rich architectural history through creation of a historic landmark district, and enhancing the quality of urban life through expanded park development.

Between Balbo Avenue and Roosevelt Road, the rehabilitation of vintage buildings into upscale residences and the construction of new condominium buildings bring new life to an area that was once plagued by urban blight. To preserve the corridor's unique character, in 2002 the Chicago City Council took the unprecedented step of designating the Michigan Avenue Boulevard District. The designation is intended to preserve aspects of the streetwall that stretches from Randolph Street on the north to 11th Street on the south.

The redevelopment of the northwest portion of Grant Park to form the new Millennium Park provides the ideal complement to the avenue's development and historic preservation activities. Millennium Park represents the largest single area of development along Central Michigan Avenue. Bounded by Michigan Avenue, Randolph Street, Columbus Drive and Monroe Street, the new park reclaims 16.5 acres of former railroad right-of-way and reconstructs 8.1 acres of the existing Grant Park.

The development and preservation efforts serve to bolster the unique and varied land uses along the avenue. A vital and growing commercial core coexists with and complements an emerging residential base. Long-established cultural institutions such as the Chicago Symphony Orchestra and the Spertus Museum interact effectively with the educational institutions—including Columbia College, Roosevelt University, and the School of the Art Institute—that have chosen to locate on the avenue in more recent decades. And new and existing parklands provide the beautiful buffer between the avenue and the city's magnificent lakefront that give the corridor its unique character.

With its exuberant mixture of vintage, modern, and contemporary structures, the avenue is an ideal location for a leisurely stroll. Indeed, the avenue is one of the city's premier tourist destinations. Walking south from the Michigan Avenue Bridge at the Chicago River to Roosevelt Road, a visitor encounters prominent cultural and commercial institutions and beautifully manicured parkland facing the lakefront. Architectural details, old and new, add texture to the streetscape. Through its many transformations, Central Michigan Avenue remains a bustling contemporary urban corridor.

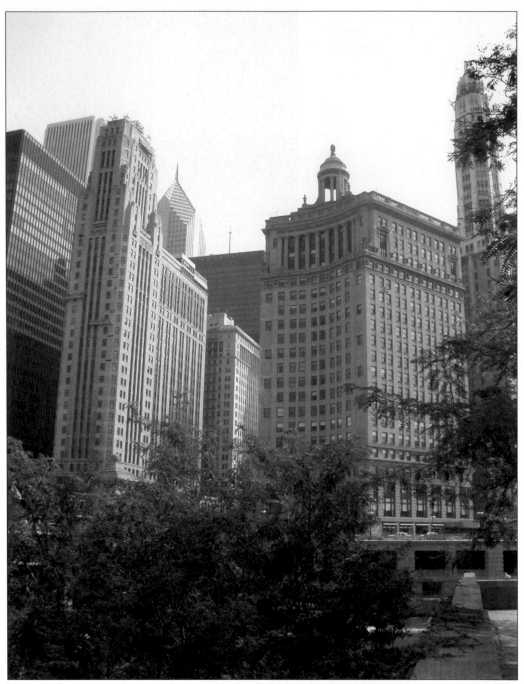

Vintage skyscrapers framing the gateway to Central Michigan Avenue are visible from the north side of the Chicago River. Modern, Art Deco, and Neoclassical skyscrapers are all visible from this vantage point. (Courtesy Anne Evans.)

Buildings along the three blocks of Central Michigan Avenue south of the Michigan Avenue Bridge create a dramatic evening urban streetscape. (Courtesy Keith Baker.)

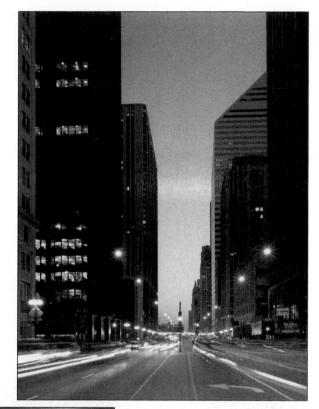

Standing on the Michigan Avenue Bridge looking north, the view is spectacular. (Courtesy Keith Baker.)

South of the Michigan Avenue Bridge, the site of Fort Dearborn is marked with plaques embedded in the paving material. (Courtesy Anne Evans.)

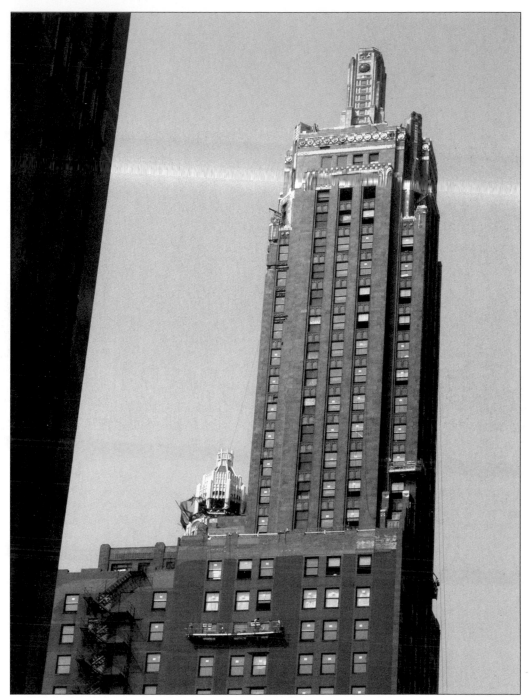

Once an office tower, the Carbon & Carbide Building at 230 North Michigan Avenue is undergoing a renovation and conversion to hotel use. The adaptive reuse design is the work of Lucien Lagrange and Associates. (Courtesy Anne Evans.)

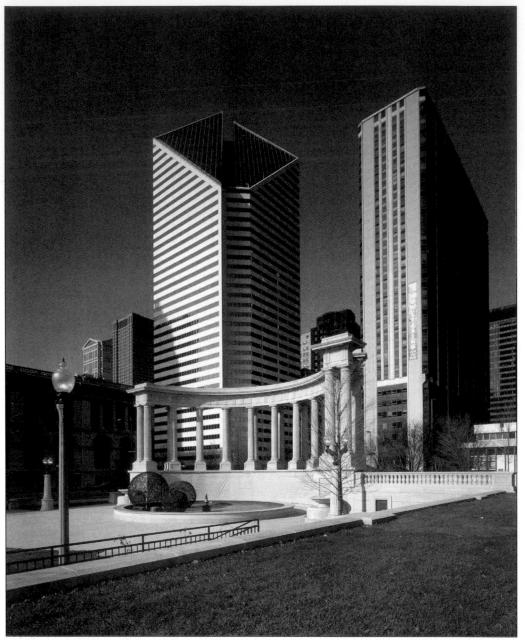

The Smurfit-Stone Building, originally the Associates Center, rises above Millennium Park's peristyle. Completed in 1984, the design by A. Epstein and Sons is noted for its dramatic sloping roofline. (Courtesy Keith Baker.)

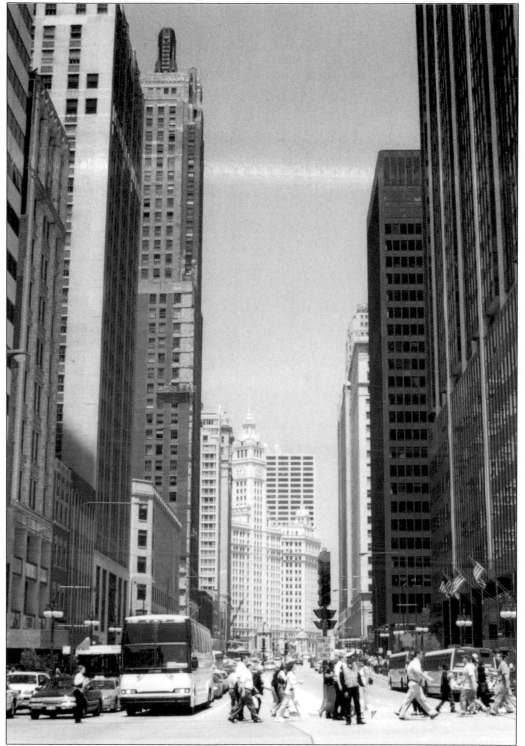

At the intersection of Michigan Avenue and Randolph Street, a strong, steady flow of pedestrians and traffic make their way before the canyon of Michigan Avenue buildings behind them.

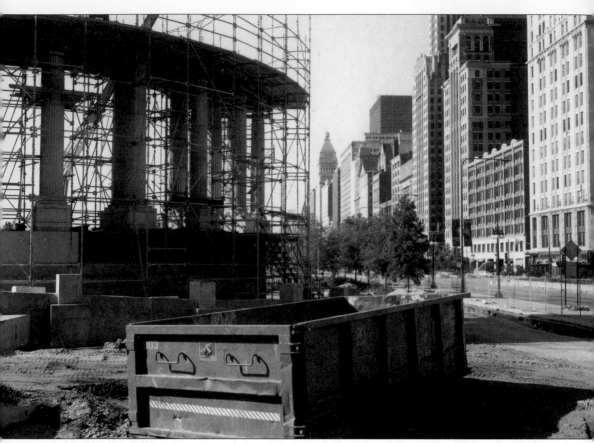

A replica of the historic peristyle is shown under construction at the southeast corner of Michigan Avenue and Randolph Street in 2002. The construction of the Peristyle marks the northern end of Millennium Park, which extends south to Monroe Street. The streetwall of vintage buildings is visible to the west. (Courtesy Anne Evans.)

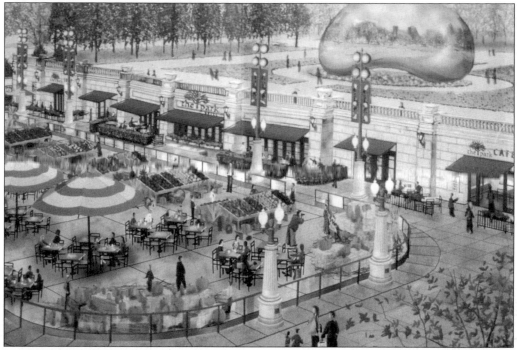

The McCormick Tribune Plaza is centrally located along Millennium Park's western edge. Used as an ice rink during winter months, the plaza is designed to operate as a large outdoor restaurant and exhibition venue in warmer weather. (Courtesy Millennium Partners.)

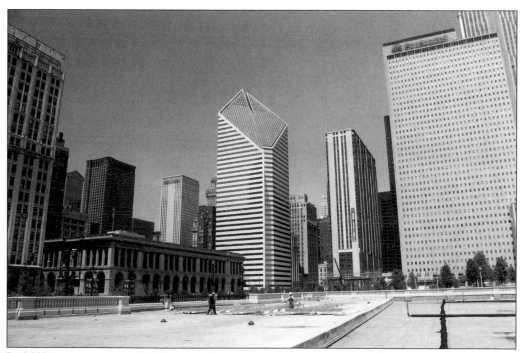

In 2002, vast portions of Millennium Park were under construction. (Courtesy Anne Evans.)

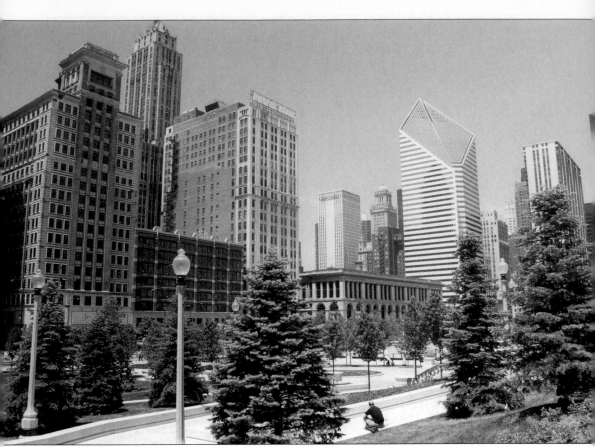

Landscaped walkways and terraces throughout Millennium Park provide places of repose along Central Michigan Avenue. From here, visitors can admire the glorious streetwall of buildings. (Courtesy Anne Evans.)

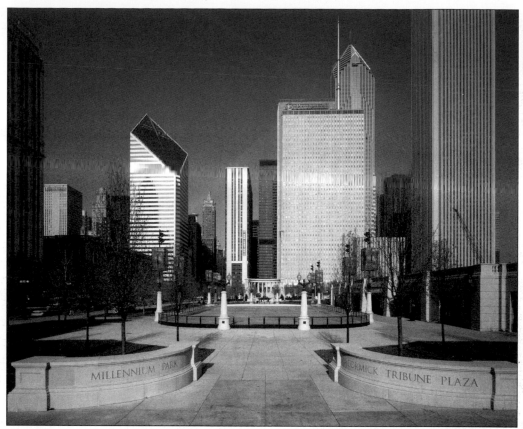

The McCormick Tribune Plaza Ice Rink is a festive winter meeting place for Chicago residents and visitors.

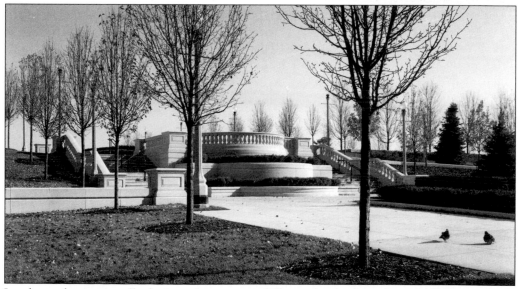

Landscaped terraces afford views from many different levels throughout Millennium Park. (Courtesy Keith Baker.)

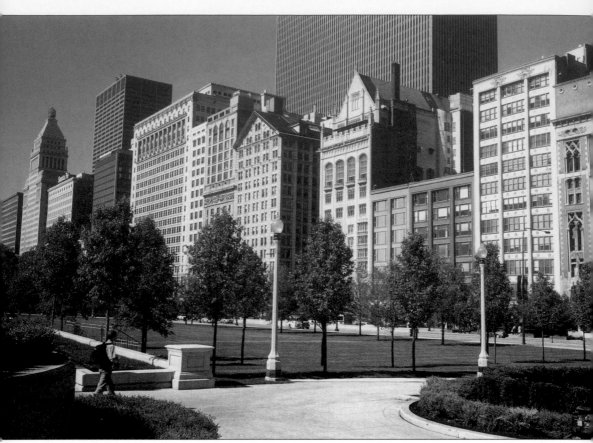

From various locations throughout Millennium Park, the Michigan Avenue streetwall can be seen beyond Jackson Boulevard to the south, left. (Courtesy Anne Evans.)

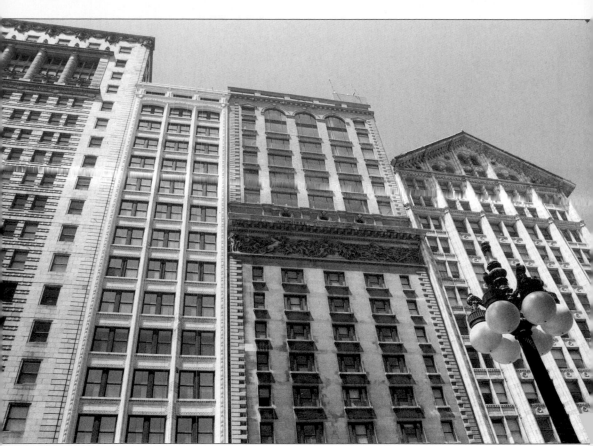

A close-up look at the streetwall along Central Michigan Avenue reveals a treasury of vintage building details. The buildings, from the left, include the People's Gas Building, 122 South Michigan Avenue; the Municipal Courts Building (Lake View Building), 116 South Michigan Avenue; the Illinois Athletic Club, 112 South Michigan Avenue; and the Monroe Building. (Courtesy Anne Evans.)

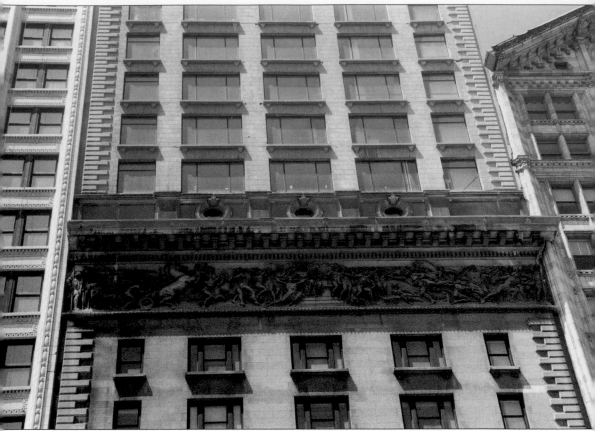

The limestone façade of the Illinois Athletic Club, 112 South Michigan Avenue, features a classical frieze of Zeus presiding over an athletic contest. (Courtesy Anne Evans.)

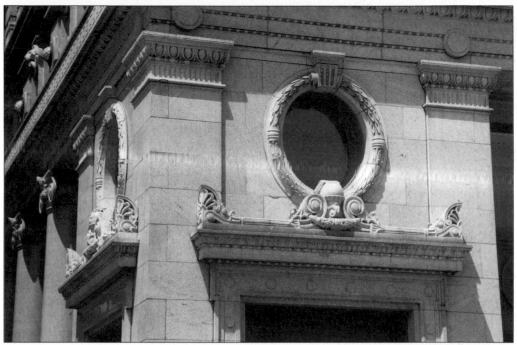

Classical ornamentation of D.H. Burnham and Company's People's Gas Building, 122 South Michigan Avenue, provides importance and character to the massive granite and terracotta building.

Planters overflowing profusely with flowering specimens of all sorts line the avenue and provide bright, seasonally changing focal points for pedestrians to enjoy. (Courtesy Keith Baker.)

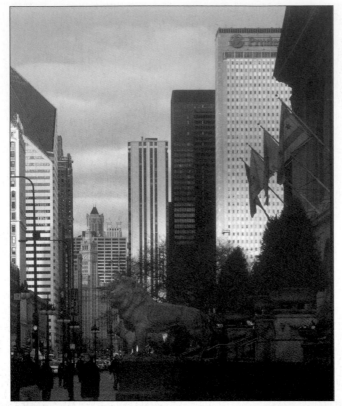

The view north from the Art Institute of Chicago is resplendent with skyscrapers in the distance. (Courtesy Keith Baker.)

Internationally renowned landscape architect Dan Kiley designed the South Stanley McCormick Memorial Court of the Art Institute of Chicago. The geometric arrangement of ornamental trees provides shady refuge to the many visitors who frequent this serene spot in warm weather. (Courtesy Anne Evans.)

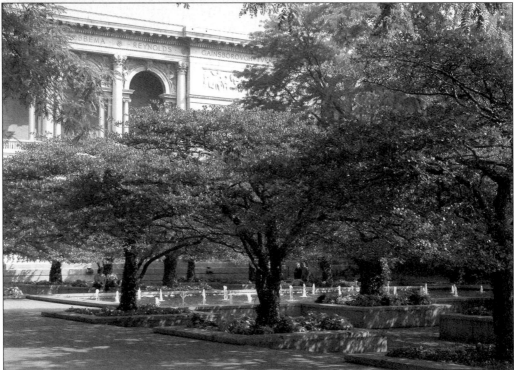

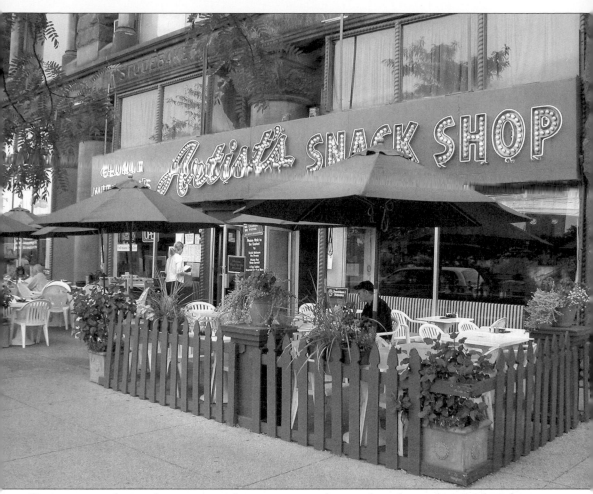

Catering to professionals, tourists, and a growing population of nearby residents and students, sidewalk cafes are an increasingly familiar summertime feature along Central Michigan Avenue. (Courtesy Anne Evans.)

The ornament around the main entrance of the Auditorum Building exemplifies the artistic skills of architect Louis Sullivan. (Courtesy Anne Evans.)

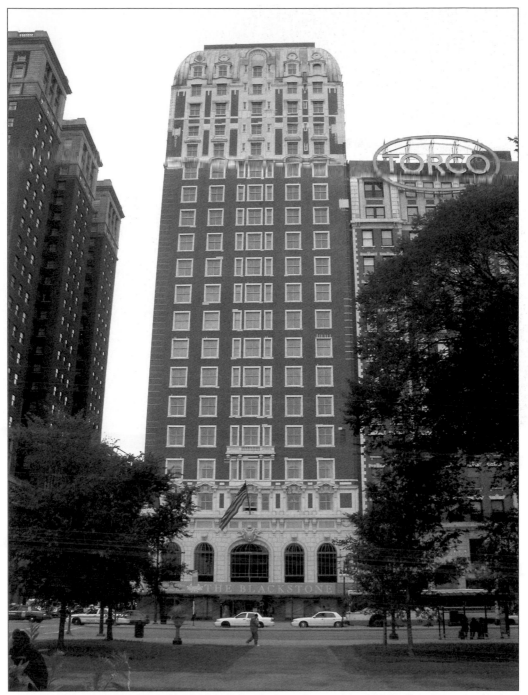

In 2002, the Blackstone Hotel, 636 South Michigan, designed by Marshall and Fox, embarked on a restoration and conversion to upscale condominium residences. The exterior of the 22-story Blackstone is clad with red brick and white glazed terracotta details. The mansard roof notably reflects the building's French Second Empire style. The restoration and conversion of this cosmopolitan gem is, to date, incomplete. (Courtesy Anne Evans.)

Classical detailing abounds at the Chicago Hilton and Towers (formerly the Stevens Hotel) at 720 South Michigan Avenue. The Stevens Hotel opened to laudatory reviews in 1927 and after many hotel transformations, including a $180 million renovation by Solomon Cordwell Buenz and Hirsch/Bender in the 1980s, it is again a top destination and host to many grand private functions. (Courtesy Anne Evans.)

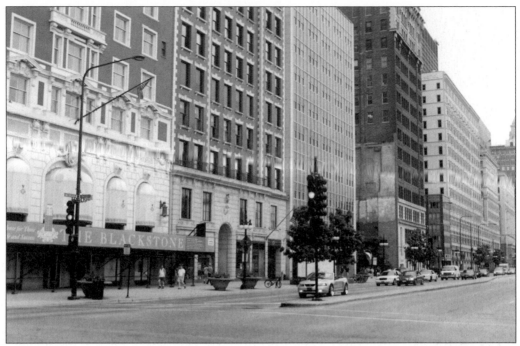

The variety of colors and textures represented by vintage and modern buildings between Balbo and Harrison Streets contribute to the character of the Michigan Avenue Streetwall. (Courtesy Anne Evans.)

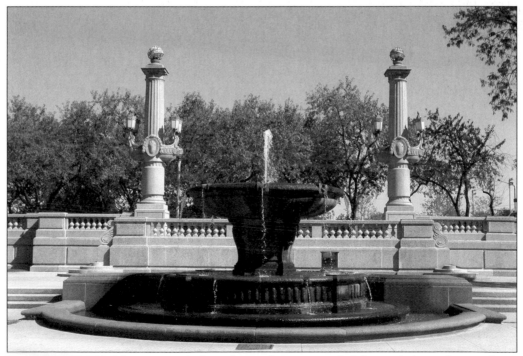

Beaux Arts-inspired features, including elegant fountains and elaborate lighting features have been preserved in many locations throughout Grant Park. (Courtesy Anne Evans.)

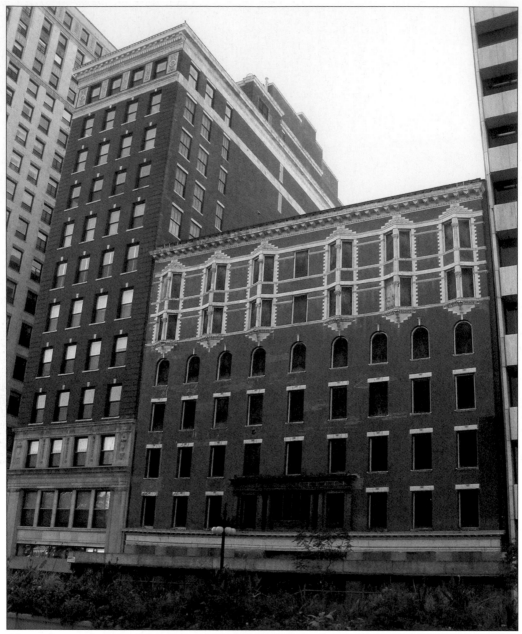

Along the south end of the Central Michigan Avenue district, vintage properties at Ninth Street and Michigan Avenue look forward to upscale residential futures. The 1913 Crane Company Building, left, was designed by Holabird & Roche to house the headquarters and showroom of the established manufacturer of plumbing fixtures. The scale and massing of the building's original design is well-suited to its current use as a residential tower.

Next door, to the right, the Young Women's Christian Association building at 830 South Michigan Avenue stands vacant, awaiting a future renovation to bring spirit and splendor back to the former residential hotel designed by John Van Osdel II. The considerable quality and attention to detail of the eclectic 1895 design, on par with the finest hotels of the period, belie the building's original charitable, not-for-profit use. (Courtesy Anne Evans.)

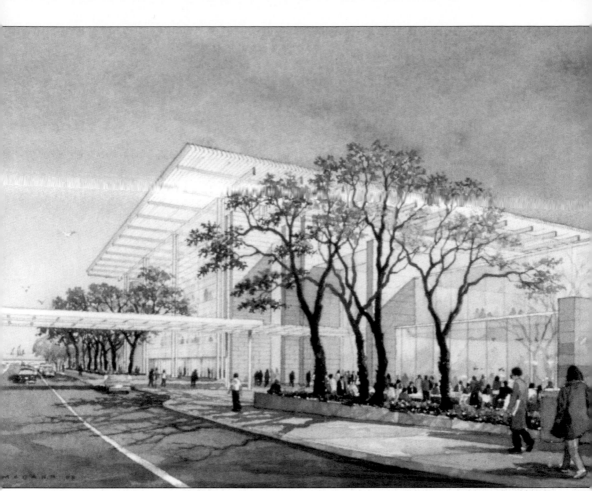

Museums and other cultural institutions located along Central Michigan Avenue continually expand their presence. The proposed expansion to the Art Institute of Chicago, designed by Renzo Piano, is scheduled for completion in 2007. (Courtesy Art Institute of Chicago.)

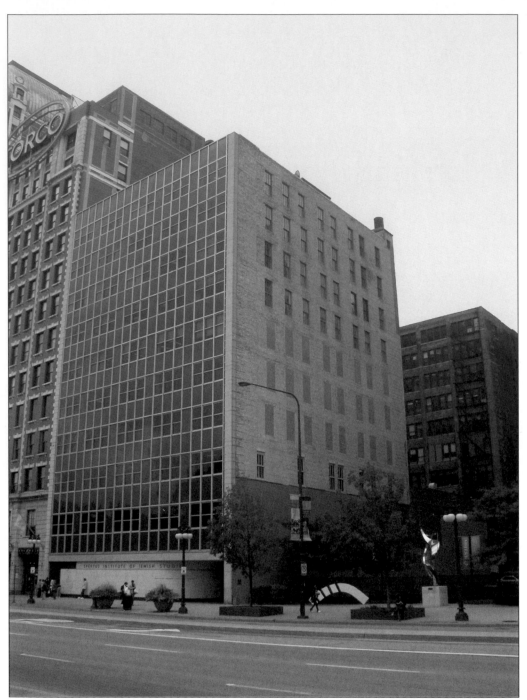

The Spertus Museum of the Spertus Institute of Jewish Studies, 618 South Michigan, is also poised for expansion. A new facility designed by Ronald Krueck of Krueck & Sexton Architects will occupy the now-vacant site north, right, of the current museum. (Courtesy Anne Evans.)

Seven

MILLENNIUM PARK

Millennium Park provides a clear example of the whole being greater than the sum of its parts. Even when those parts are as impressive as an outdoor music pavilion designed by internationally renowned architect Frank O. Gehry and a 50-foot, interactive fountain created by Spanish artist Jaume Plensa, the impact of an integrated, 24.5-acre park that realizes Daniel Burnham's original vision for Chicago's lakefront parks is even more stunning than its components.

Lush, verdant shrubbery, tall rows of mature trees, and billowing beds of colorful flowering specimens adorn the vast site. The park's landscape centerpiece, Monroe Garden, is designed by Kathryn Gustafson in collaboration with Piet Oudolf and Robert Israel. The design of the 2.5-acre garden calls for 250 varieties of perennial plants native to Chicago.

In addition to Millennium Fountain, which will feature water cascading down two glass towers that project an ever-changing array of light and visual images, the park contains several significant sculptural elements. The first is an 18-ton, stainless-steel bean-shaped sculpture designed by Indian-born artist Anish Kapoor. The surface of the 60-foot long sculpture at Madison Street and Michigan Avenue is intended to reflect the park and the avenue's streetwall.

Another remarkable work of art, the Gehry-designed Music Pavilion, is marked by a series of stainless steel ribbons that envelope the concert stage. The pavilion's fixed seating area and great lawn can accommodate audiences of up to 11,000, and a unique trellis of steel arches above the lawn contains a state-of-the-art open-air sound system. A stainless-steel pedestrian bridge across Columbus Avenue, envisioned by the architect as a complement to his bandshell, completes the design.

A more traditional sculptural element, a peristyle of Doric limestone columns, anchors the park's northwest corner at Michigan Avenue and Randolph Street. A neo-classical element, the Millennium Monument, designed by OWP/P Architects is a near-replica of an earlier peristyle, designed by Chicago architect Edward Bennett and built in 1917 on the same site.

A restaurant, an ice skating rink and a promenade are among the park's other prominent features. And the 1,500-seat Music and Dance Theater Chicago, designed by the Chicago architecture firm Hammond Beeby Rupert Ainge, provides a performance space for more than a dozen local arts organizations.

The park provides an urban recreational and cultural amenity to the growing population of nearby residents and tourists. Whether it is providing a venue for thousands of concertgoers or an oasis for an individual seeking a respite from urban life, Millennium Park represents a dramatic and valued addition to the avenue and the city.

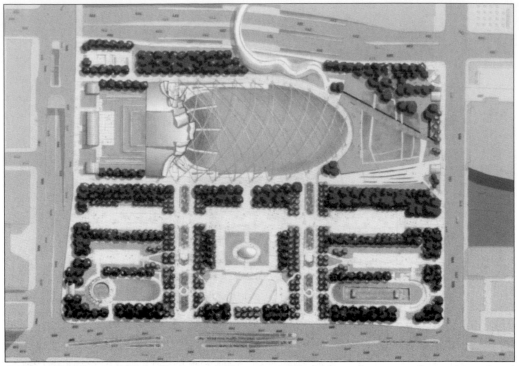

A plan of Millennium Park illustrates the location of the various features and amenities placed throughout the 24-acre site. The oval Great Lawn that spreads before the Frank Gehry-designed bandshell is prominently visible along the park's eastern edge. (Courtesy Millennium Partners.)

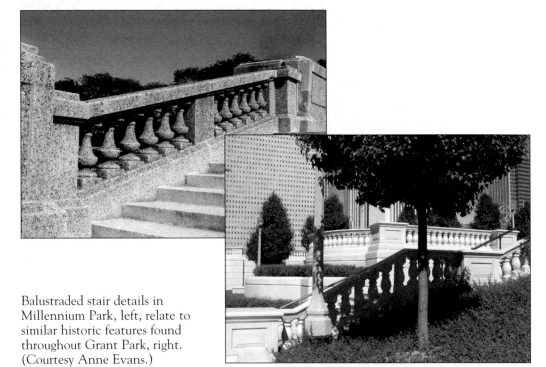

Balustraded stair details in Millennium Park, left, relate to similar historic features found throughout Grant Park, right. (Courtesy Anne Evans.)

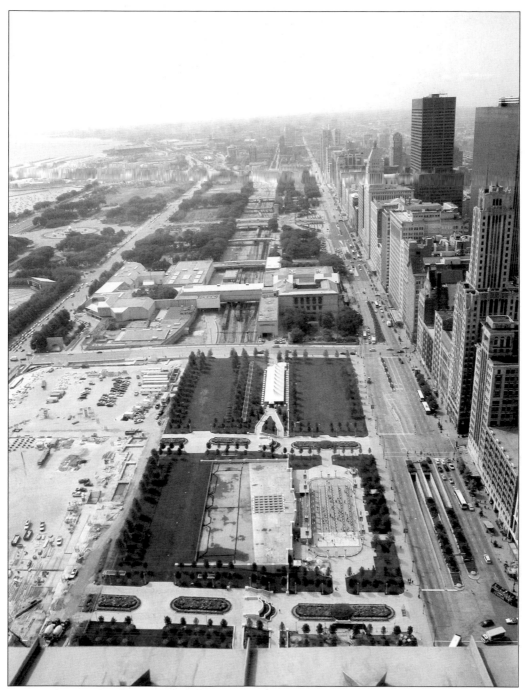

An aerial view of Millennium Park under construction shows its relationship to the avenue and the streetwall of buildings. (Courtesy New World Design Partners.)

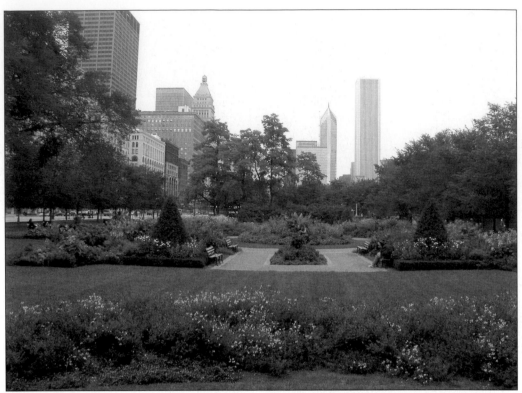

Beautifully planted formal gardens are once again characteristic of Grant Park, adjacent to Central Michigan Avenue. (Courtesy Anne Evans.)

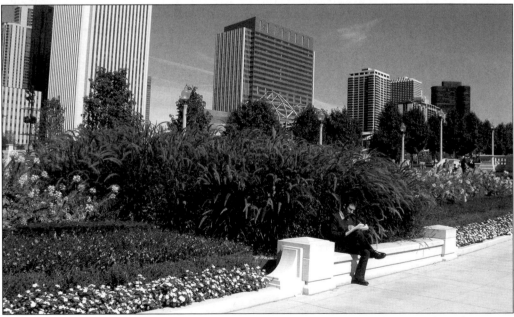

Lush landscaping makes Millennium Park a delightful place to play or relax. (Courtesy Anne Evans.)

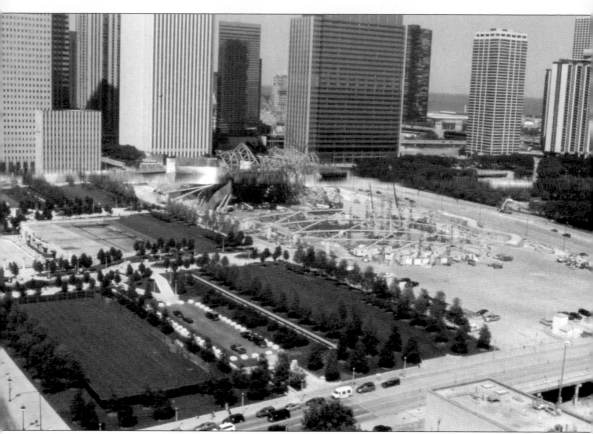

Viewed from above, the Millennium Park Music Pavilion, designed by world-renowned architect Frank Gehry and shown under construction in 2003, spreads out below surrounding skyscrapers to the north, including the Aon Center and Blue Cross Blue Shield Building. (Courtesy Lydia Uhlir.)

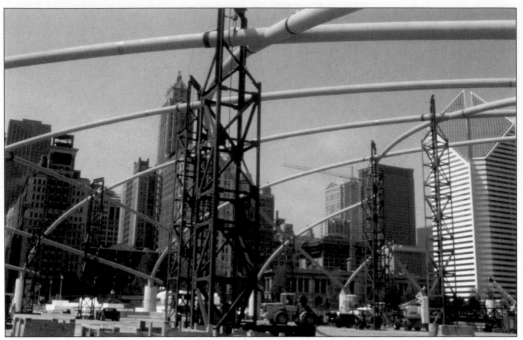

A trellis shaped like a flattened dome and constructed of curved steel pipes will span the Great Lawn of Millennium Park. Shown under construction in 2003, the net-like structure will house decorative lighting and sound amplification systems. (Courtesy Lydia Uhlir.)

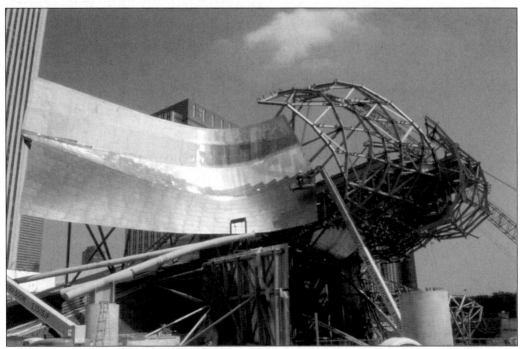

The performance shell of the Music Pavilion is characteristic of Frank Gehry's work. Curving stainless-steel-covered panels, resembling ribbon-like petals, are shown during initial stages of construction in 2003. (Courtesy Lydia Uhlir.)

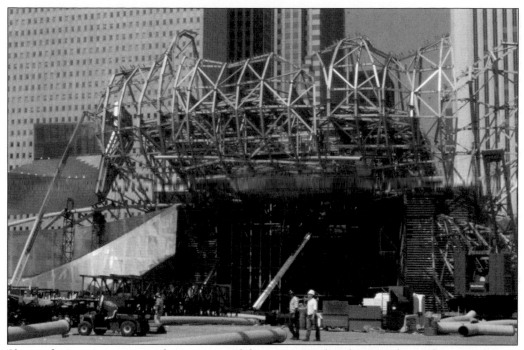

Shown during construction, the armature of the Music Pavilion hints at the exuberant stainless-steel-covered bandshell that will soon materialize in Millennium Park. (Courtesy Lydia Uhlir.)

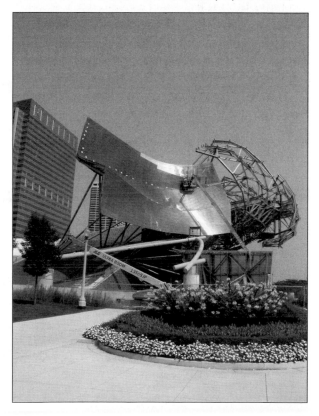

The restrained and manicured look of well-tended beds of seasonal plantings in the foreground provides a contrast to the outspoken architectural expression under construction behind. (Courtesy Anne Evans.)

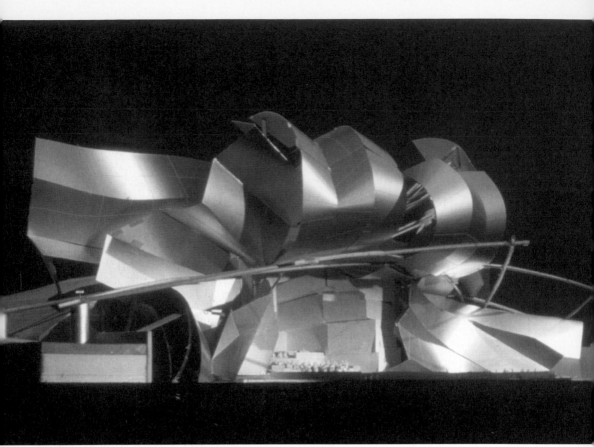

The spectacular effect of the enveloping mass of stainless steel ribbons surrounding the stage of the Millennium Park Music Pavilion is evident on this project model. (Courtesy Frank O. Gehry.)

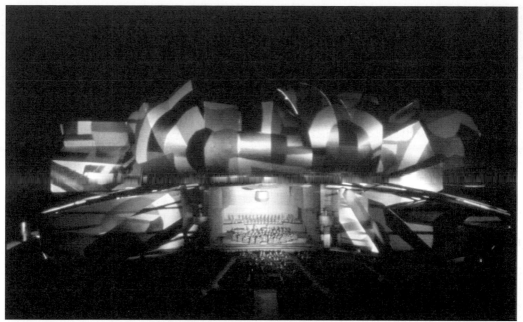

Stunning displays of projected light will be played out regularly against the riot of stainless steel ribbons framing the Music Pavilion stage, as shown on this project model. (Courtesy Frank O. Gehry.)

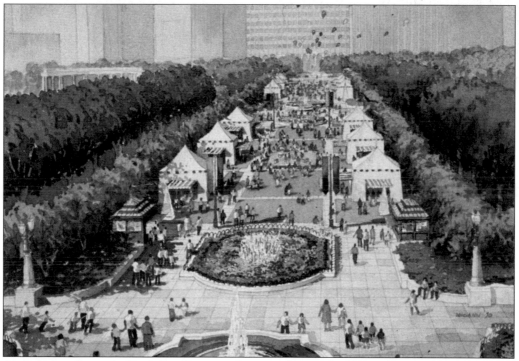

A rendering shows the Bank One Promenade, a grand central walkway that traverses the north-south axis of Millennium Park. Tents will be used for various activities related to special events, exhibits, and festivals. (Courtesy Skidmore, Owings, & Merrill.)

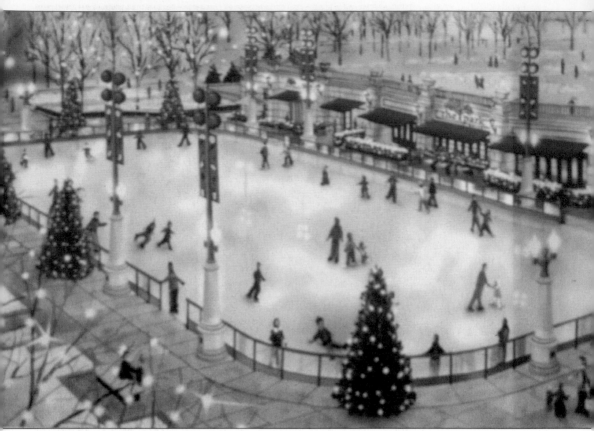

A rendering illustrates the placement of the sculpture designed by Anish Kapoor in a prominent location in Millennium Park's SBC Plaza, overlooking the McCormick Tribune Plaza Ice Rink. (Courtesy Aria Group Architects.)

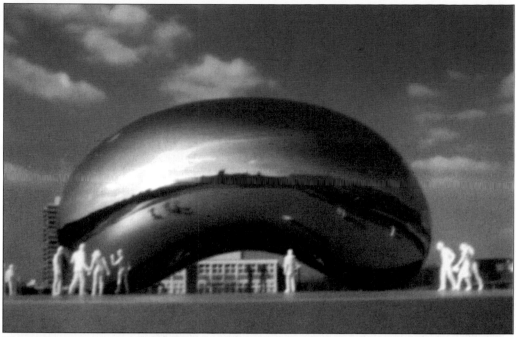

The enormous size of Anish Kapoor's sculpture, measuring 60 feet long and 30 feet high, is suggested by this drawing of Millennium Park. (Courtesy Anish Kapoor.)

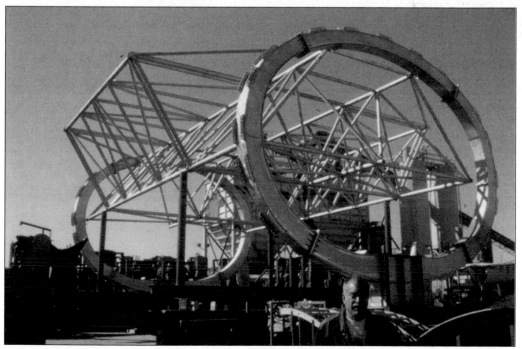

Fabrication of Kapoor's sculpture is taking place in California. The armature of the sculpture, shown behind a fabricator, will be covered in a highly reflective and seamless stainless steel skin before the piece, weighing over 100 tons, is transported to Chicago for installation in Millennium Park. (Courtesy U.S. Equities.)

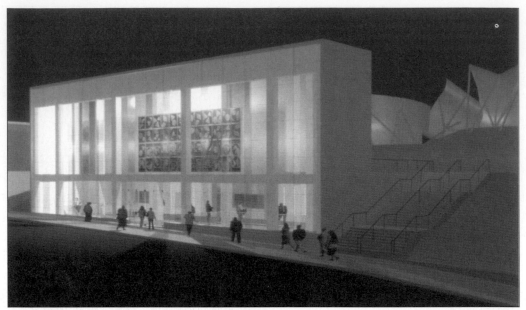

The entrance to Millennium Park's Music and Dance Theater Chicago, designed by Hammond Beeby Rupert Ainge, faces Randolph Street, west of Columbus Drive. The 1,500-seat theatre, mostly immersed underground and largely covered by park landscape, will be home to 12 performing arts groups, including the Joffrey Ballet of Chicago. (Courtesy Hammond Beeby Rupert Ainge.)

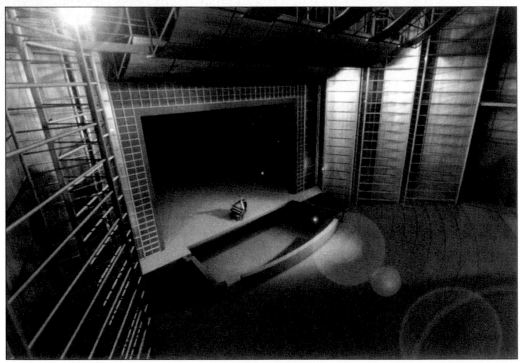

The stage of the $52 million state-of-the-art Music and Dance Theater Chicago is shown in this rendering. (Courtesy Hammond Beeby Rupert Ainge.)

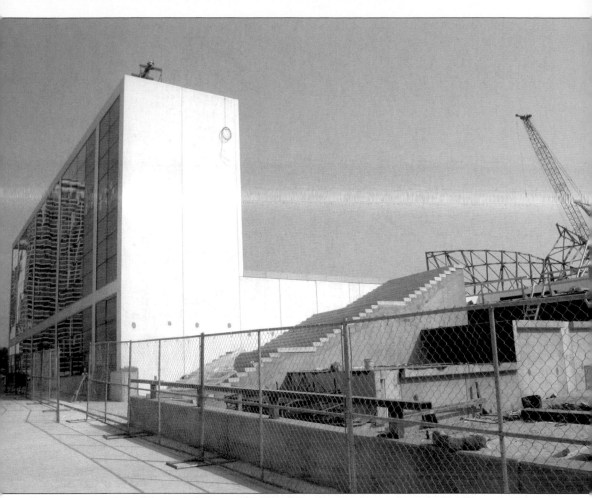

Construction of the Music and Dance Theater Chicago on the north end of Millennium Park in 2003. (Courtesy New World Design Partnership.)

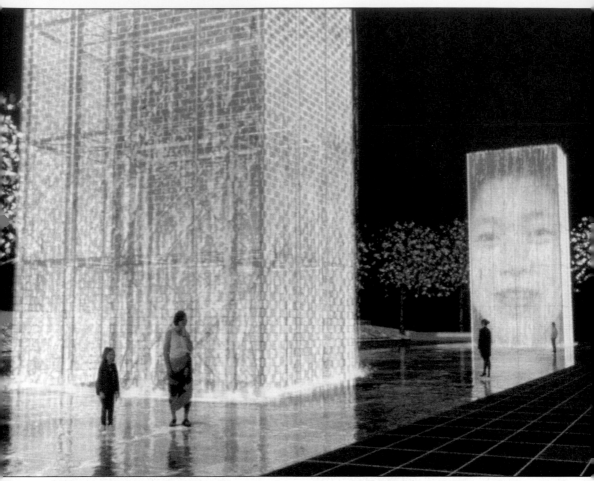

Millennium Fountain, designed by artist Jaume Plansa of Barcelona with Krueck & Sexton of Chicago, will provide visual and aural stimulation to visitors. While water cascades from the top of two 50-foot high glass block towers, a constantly changing exhibition of lights and computerized electronic images will reflect against the wide shallow pool. (Courtesy OWP/P.)

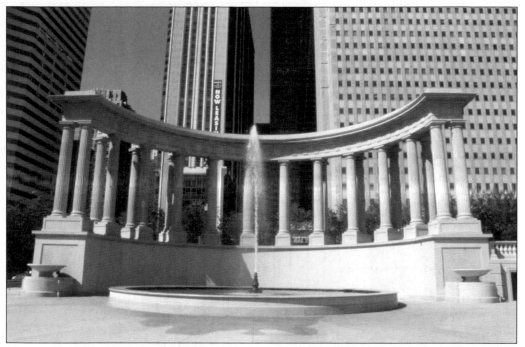

Names of Millennium Park benefactors will be inscribed on the base of the Millennium Monument in Wrigley Square. A nearly full-sized replica of Edward Bennett's 1917 original, the Millennium Monument peristyle designed by OWP&P is composed of a semi-circular arrangement of paired Doric limestone columns resting upon a tall base. (Courtesy Lydia Uhlir.)

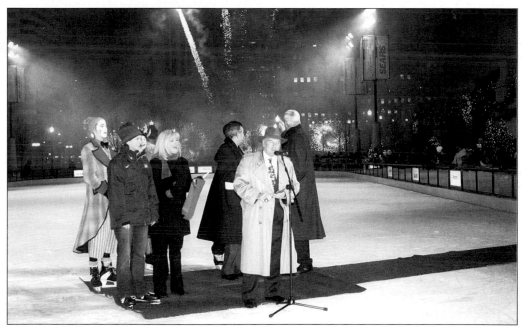

Mayor Richard M. Daley and actress Bonnie Hunt cut a ceremonial ribbon to signify the official opening of the McCormick Tribune Plaza Ice Rink in December, 2001. (Courtesy Chicago Park District.)

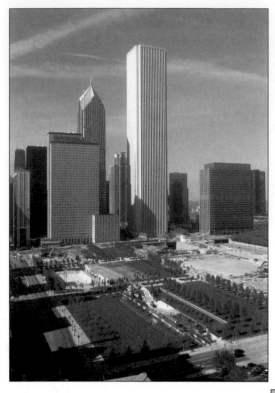

Millennium Park spread before a backdrop of notable Chicago skyscrapers, including the Prudential Building, Aon Center, and the Blue Cross Blue Shield Building. (Courtesy Keith Baker.)

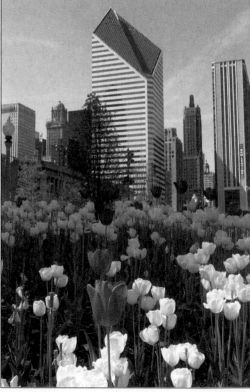

Masses of tulips in Millennium Park frame a view of the Central Michigan Avenue streetscape. (Courtesy Chicago Park District.)

Eight

A PHOTOGRAPHIC WALK
ALONG THE AVENUE

Photographs by Hedrich Blessing

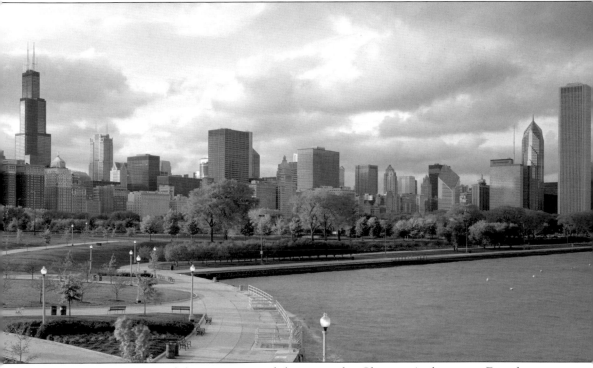

Originally commissioned for use in an exhibition at the Chicago Architecture Foundation, these images by the acclaimed photographers Hedrich Blessing capture the urban beauty and vitality of Central Michigan Avenue. The collection of photographs presents views of the Central Michigan Avenue district, from its south end at Roosevelt Road to its north end at the Michigan Avenue Bridge over the Chicago River. These images beautifully illustrate the dialogue enjoyed between the spectacular architecture of the Michigan Avenue streetwall and the grand plazas, parkways, and promenades of Grant Park and Millennium Park.

Hedrich Blessing.

Hedrich Blessing.

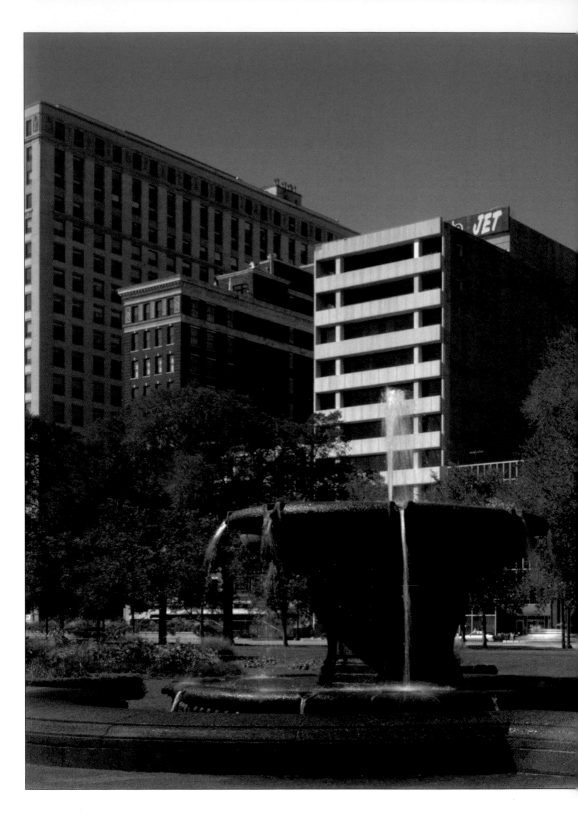

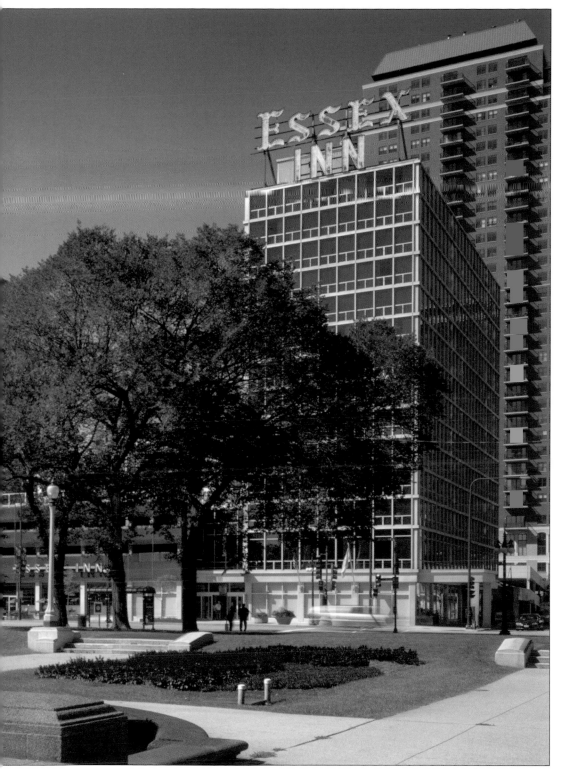

Hedrich Blessing.

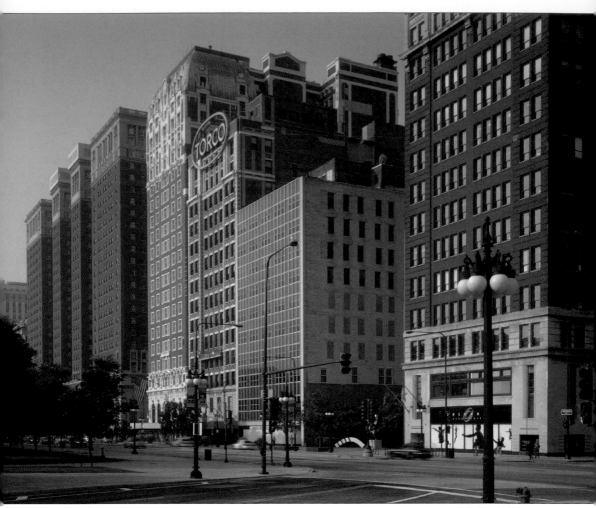

Hedrich Blessing.

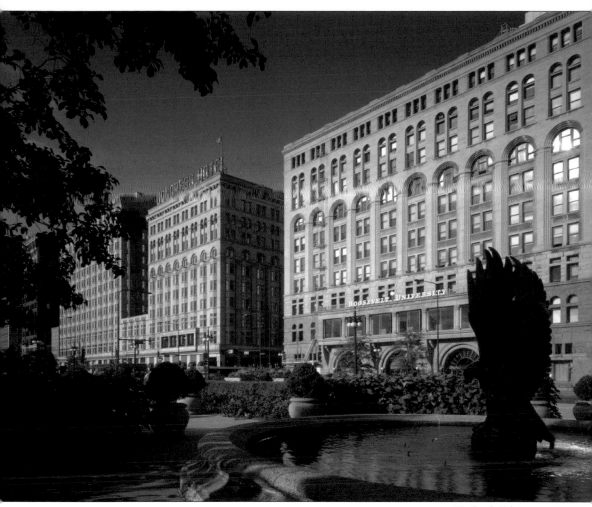

Hedrich Blessing.

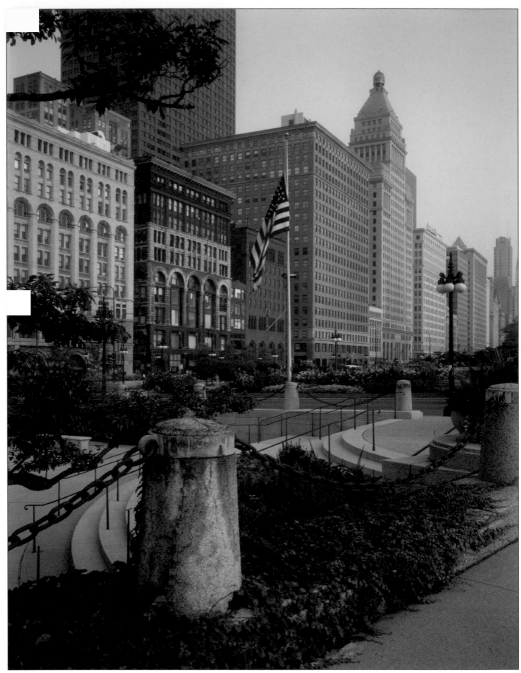

Hedrich Blessing.

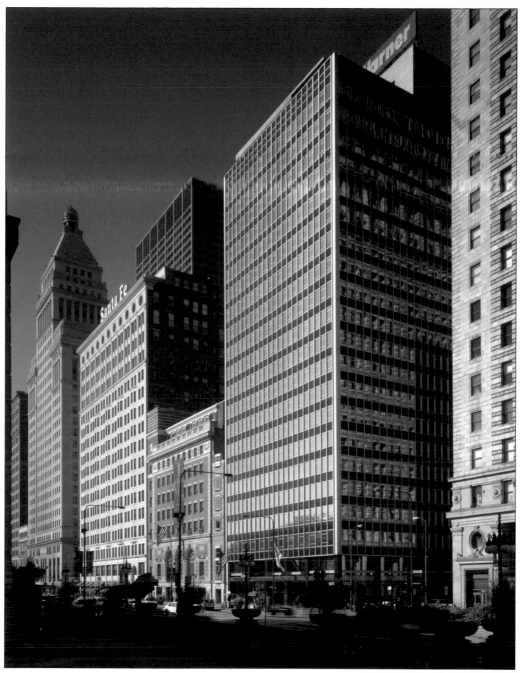

Hedrich Blessing.

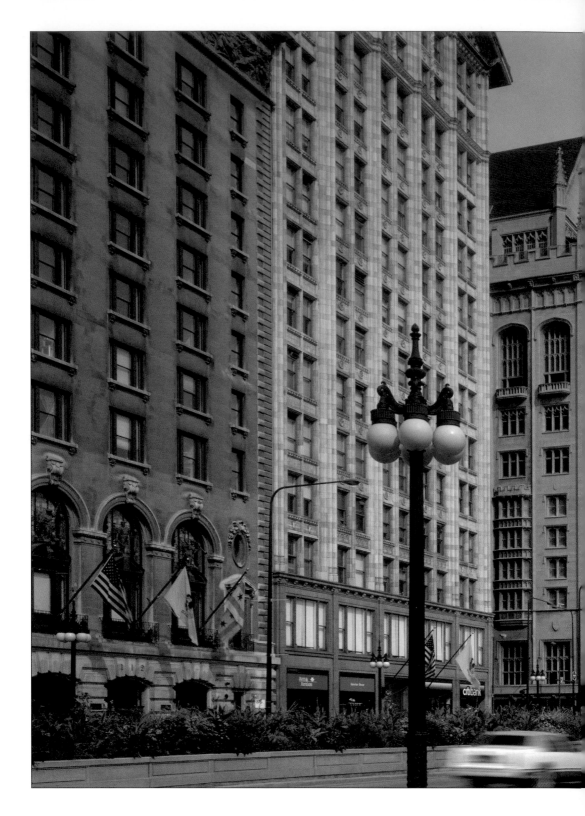

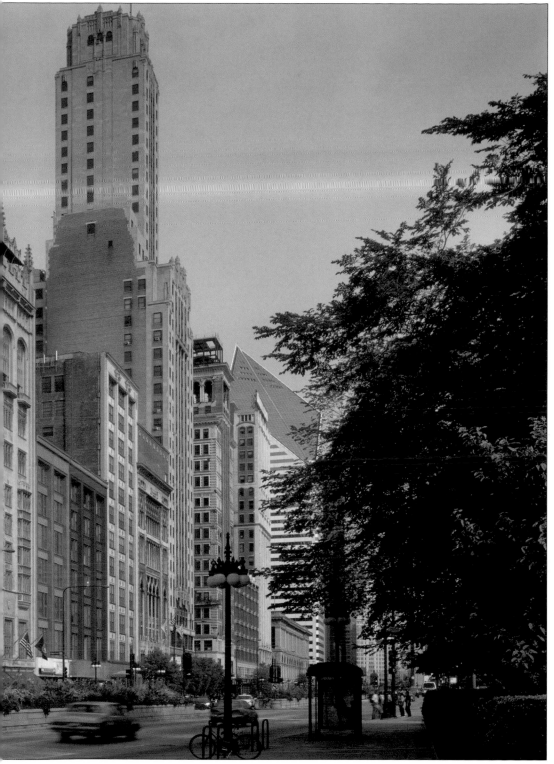

Hedrich Blessing.

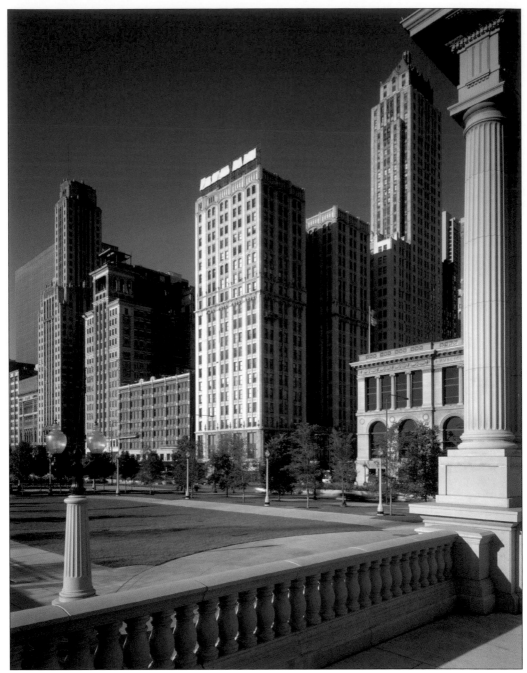

Hedrich Blessing.

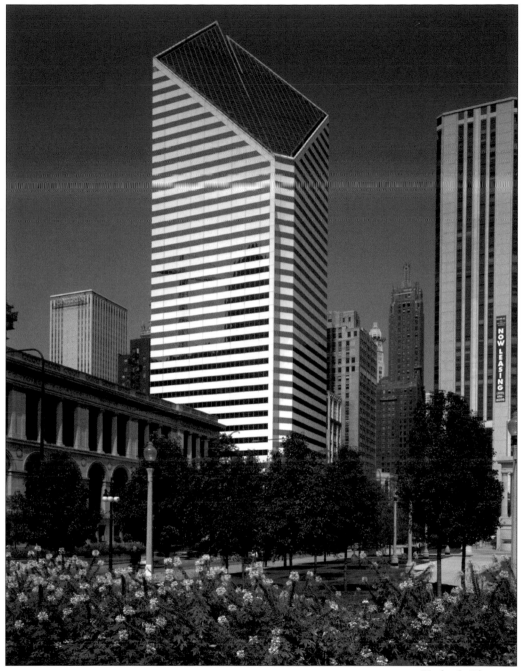

Hedrich Blessing.

141

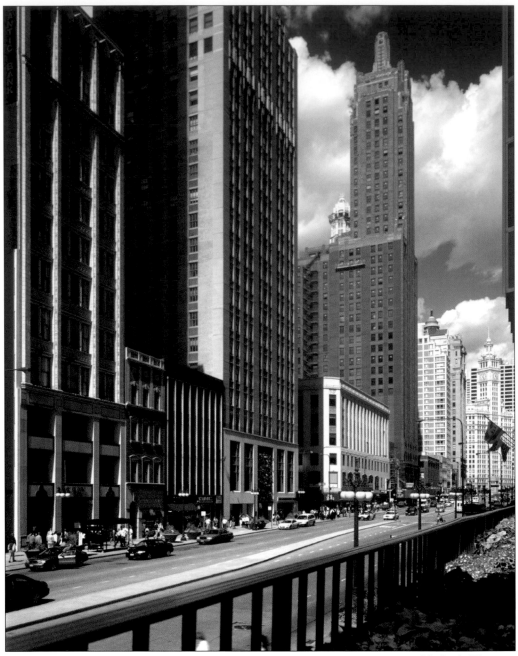

Hedrich Blessing.

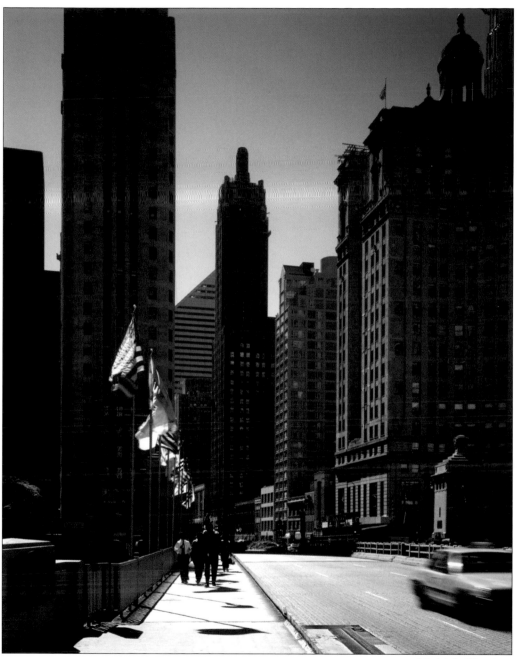

Hedrich Blessing.

Selected Bibliography

Commission on Chicago Landmarks. *Historic Michigan Boulevard District*. (Chicago: City of Chicago Department of Planning and Development, 2001.)

Mayer, Harold M. and Wade, Richard C. *Chicago: Growth of a Metropolis*. (Chicago: University of Chicago Press, 1969.)

New World Design Partnership and the R. Holden Group. *Chicago Modern Architecture: A Virtual Walking Tour on CD-ROM*. (Chicago: Chicago Architecture Foundation, 2002.)

Oculus Visualization and the R. Holden Group. *Chicago Historic Architecture: A Virtual Walking Tour on CD-ROM*. (Chicago: Chicago Architecture Foundation, 2001.)